A DIFFERENT WAR

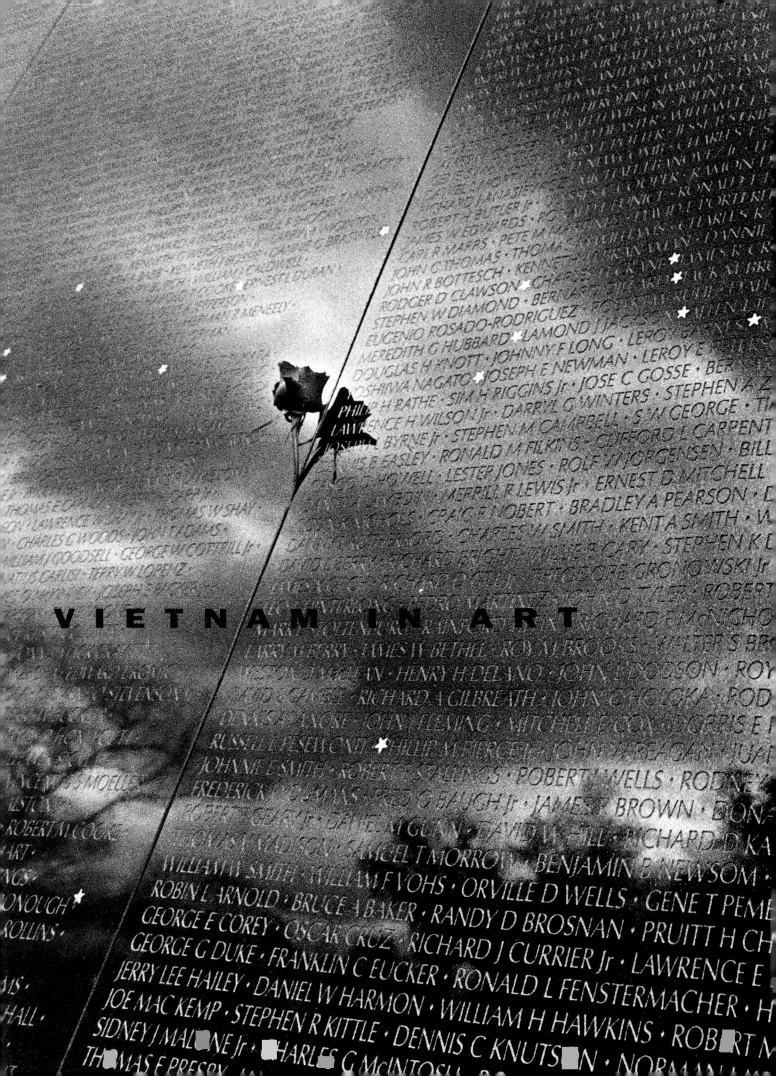

V I E T N A M I N A R T

A DIFFERENT

WAR

LUCY R. LIPPARD

WHATCOM
MUSEUM
OF
HISTORY
AND
ART

·

☄

THE
REAL
COMET
PRESS

·

SEATTLE
1990

Partial names visible on the Vietnam Veterans Memorial wall:

RD S MOHN
OGGARD
TREVISANO
RAFAEL E BEECH
DWYER

BESCHEN

CLIFFORD S BRATCHE
JAMES FASKIN · CLIFFORD S BRATCHE
THY S DAVIES · DAVID A DILLON ·
BRENT I GRIGGS · EDWARD F HAP ·
NELSON · DOUGLAS M KYSER ·
ONALD J KINKEADE · WILLIAM H NELSON ·
ID E PETERS · CHARLES S RIDOUT ·
ER R TATE Jr · DONALD C WOODRUFF ·
3 · DOUGLAS R FRENCH ·
ENNIS L HARMON · SAMUEL G HARRIS ·
PULLIAM Jr · WILBERTO CABRERA SANCHEZ
LARRY VAN CLIEF · OSCAR C BELL Jr
N · EDWARD W BUTLER ·
ORES MENO · MAXWELL S FRANTZ
Y A JAMES · PAUL W JOHNSON ·
TON · JOHN W PERICH ·
EGO SANCHEZ · CHESTER J SIMMONS ·
WESTCOTT · GARLAND F WRIGHT
G DAVENPORT · MELVIN FORD ·
· JARVIS C LOWDER ·
BERT L WENGER · STEVEN O SCHULTZ
TON · WILLIE W WILKERSON ·
NEY · RONALD P COATES ·
NIELS · LAWRENCE E DENNY ·
H C GALBRAITH · CHARLIE GRAY ·
ULSE · ROBERT

A Different War is a copublication of the Whatcom
Museum of History and Art and the Real Comet Press,
a division of Such A Deal Corporation. For further
information: The Real Comet Press, 3131 Western
Avenue, #410, Seattle, Washington 98121-1028.
Tel: 206-283-7827.

Edited by James Liljenwall and Miriam Roberts.
Designed by Marquand Books, Inc.

Printed in Hong Kong.

Library of Congress Cataloging-in-Publication Data
Lippard, Lucy R.
 A different war : Vietnam in art / Lucy R. Lippard.
 p. cm.
 Exhibition circulated by Independent Curators,
 Incorporated.
 Includes bibliographical references.
 ISBN 0-941104-43-5 : $18.95
 1. Vietnamese Conflict, 1961–1975—Art and the
war—Exhibitions. 2. Art, American—Exhibitions. 3. Art,
Modern—20th century—United States—Exhibitions.
I. Whatcom Museum of History and Art. II. Independent
Curators Incorporated. III. Title.
N6512.L57 1990
704.9'499597043'07473—dc20 89–70103

Front cover: Rupert Garcia, *Fenixes*, 1984 (cat. no. 29).
Back cover: Jerry Kearns, *Madonna and Child*, 1986
(fig. 79).
Frontispiece: Wendy Watriss, detail. *Untitled*, from the
"Vietnam Veterans Memorial" series, 1982 (cat. no. 99).

Exhibition circulated by Independent
Curators Incorporated, New York, a
nonprofit traveling exhibition service
specializing in contemporary art.

Exhibition Itinerary

Whatcom Museum of History and Art
Bellingham, Washington
August 19–November 12, 1989

De Cordova Museum and Sculpture Park
Lincoln, Massachusetts
February 17–April 15, 1990

Mary and Leigh Block Gallery
Northwestern University
Evanston, Illinois
May 9–June 24, 1990

Akron Art Museum
Akron, Ohio
September 8–November 4, 1990

Madison Art Center
Madison, Wisconsin
December 1, 1990–January 27, 1991

Wight Art Gallery, UCLA
Los Angeles, California
March 24–May 19, 1991

CU Art Galleries
University of Colorado
Boulder, Colorado
August 30–October 5, 1991

Museum of Art
Washington State University
Pullman, Washington
January 13–February 23, 1992

PREFACE

The Whatcom Museum is proud to present *A Different War*. For us it represents a rare opportunity to offer an important new area of art history for critical examination. That the works themselves result from deeply felt attitudes and emotions makes it doubly significant. Curatorial researches resulting in museum exhibits seldom have this dual genesis. I am particularly impressed at the commitment of staff and support by the Board in development of the exhibit. I would like to especially acknowledge John Olbrantz for his hard work and dedication. The viewing public, at any level of familiarity with the Vietnam War or recent art history, cannot help but be impressed with this demonstration of personal courage by artists, veterans, and refugees and cannot fail to be moved by their images. For all those who have made the exhibit possible, we are most appreciative. For all those who see it we are honored to present *A Different War*.

George E. Thomas
Director
Whatcom Museum of History and Art

F O R E W O R D

The Vietnam War had a powerful impact on American culture, yet its influence on American art has not yet been fully explored. After a decade of avoidance, repression, and silence, Americans are finally coming to terms with a war that deeply divided our country. As scholars, veterans, peace activists, and others have begun to assess the impact of the war on American history and culture, it is highly appropriate that an exhibition be organized that explores its impact on recent American art history.

A Different War is the result of nearly four years of research and is destined, we hope, to make a significant contribution to American art scholarship. As the first critical examination of the impact of the Vietnam War on American art of the past twenty-five years, the exhibition and accompanying publication will write an important chapter of recent American art history, a chapter that has been too painful, personal, or political to properly assess in the past.

A project of this magnitude would not be possible without the help and support of a number of creative and talented individuals, and I would like to take this opportunity to thank them for their commitment and support.

I would like to thank the Board of Trustees of the Whatcom Museum of History and Art, and Director George Thomas in particular, for their ongoing commitment to the project over the past two years. On the WMHA staff, I would like to thank Michael Jacobsen, Exhibit Designer; Nancy Jones, Exhibit Registrar; Curt Mahle, Exhibit/ Maintenance Assistant; Kathy Green, Public Relations Coordinator; Richard Vanderway, Edu-

cation/Public Programs Coordinator; Gladys Fullford, Office Manager; Kathi Morris, Membership Secretary; Nancy Deasy, Gallery Attendant; and Julie Hadley, Gallery Attendant. I am further indebted to a number of other staff members who, although not directly involved with the project, helped with various aspects of the exhibition: Jan Olson, Curator of Collections; Craig Garcia, Archivist; Trish Navarre, Membership Coordinator; and Pat Dowling, Custodian. Without the help and support of these talented and committed professionals, *A Different War* would not have been possible.

The idea for *A Different War* occurred to me a number of years ago as I was driving north from Seattle to Bellingham on the freeway. A song came on the radio that I hadn't heard for years: Country Joe McDonald's "I-Feel-Like-I'm-Fixin'-To-Die Rag." As I listened to the lyrics, the song triggered in my memory thoughts of the late 1960s and Vietnam. Although I had been a student in the art department at Western Washington University during this tumultuous period, and had made frequent trips to Seattle to see various art exhibitions, I was not aware of any artists who were dealing specifically with the Vietnam War in their art. As Country Joe sang on, I wondered if there were artists in New York, Chicago, and Los Angeles who had chosen to speak out against the Vietnam War. At the same time, I wondered what kind of impact the Vietnam War had on the art of Vietnam veterans. I decided that it was a curatorial idea warranting further exploration, and I lodged it in the back of my mind for future reference.

When I moved to San Jose, California, in the mid-1980s to assume the directorship of the San Jose Museum of Art, I resurrected the idea and began to explore it further. I decided to contact Lucy Lippard to see if she would be willing to curate the exhibition and write the essay for the exhibition catalogue, and she enthusiastically agreed.

As one of the foremost art writers in the United States, and as a political activist for the past twenty years, Lucy is intimately aware of the forces that shaped American art during the Vietnam era, and I am most grateful to her for her commitment and support of the project over the past four years. Her thoughtful selection of objects in the exhibition and her insightful essay in this catalogue have shed new light on this important, yet largely forgotten, aspect of recent American art history.

I am further indebted to Jim Liljenwall and Mimi Roberts of Berkeley, California, for their skillful editing of the catalogue text. Mimi was Chief Curator at the San Jose Museum of Art and has been closely involved with the exhibition and publication from the beginning. Her friendship and support over the years have been extremely important to me, and I am delighted that we have been able to see the project come to fruition. In addition, I would like to thank Ed Marquand and Suzanne Kotz of Marquand Books, Inc., for their beautiful design of the exhibition catalogue, and The Real Comet Press for agreeing to copublish the book.

A Different War has been made possible, in part, by grants from the National Endowment for the Arts, the California Arts Council, the Washington State Arts Commission, and an anonymous donor, and I am most grateful to them for their belief in our ability to carry out such an ambitious project. I am further indebted to a number of Bellingham individuals and businesses for their ongoing support of the Whatcom Museum of History and Art: Mr. and Mrs. Jack Dunkak, Mr. and Mrs. Fielding Formway, Mr. Stuart R. Graham, Brown and Cole Stores, Chemco, Inc., Georgia-Pacific Corporation, Northwest Commercial Bank, Seattle First National Bank, Bellingham Sash and Door, Morse Hardware, Mt. Baker Bank, and Peoples State Bank.

When it became apparent that there was tremendous national interest in *A Different War*, I approached Independent Curators Incorporated in New York to determine their willingness to circulate the exhibition, and they enthusiastically agreed. I would like to express my thanks to Susan Sollins, Executive Director; Judith Olch Richards, Associate Director; Lise Holst, former Exhibition Coordinator; Donna Harkavy, current Exhibition Coordinator; and Jack Coyle, Registrar. Moreover, I would like to thank those institutions participating in the national tour.

Finally, and by no means last, I would like to thank the many artists and lenders who agreed to part with their works for an extensive two-year national tour. Although I cannot thank each one individually here, their names appear in other parts of this catalogue.

Little of the art in *A Different War* is pleasant to look at. Much of it expresses outrage and anguish. Much of it conveys deep sadness, loss, unease—even madness. And yet, as Jock Reynolds, Executive Director of the Washington Project for the Arts in Washington, D.C., has said:

> We can circumvent, avoid and repress our history, and encourage our culture to be more decorative, distracting, and vapid, or we can directly face this part of our national history if artists choose to participate in a struggle for needed understanding as they see fit. As we yearn for peace and beauty, for masterpieces of harmony and resolution, difficult and disturbing subjects must not be avoided. Those willing to tackle them deserve support and encouragement, for there is beauty in such work too.

John Olbrantz
Deputy Director
Whatcom Museum of History and Art

ACKNOWLEDGMENTS

It is a special pleasure for ICI to collaborate with the Whatcom Museum of History and Art on the organization of *A Different War: Vietnam in Art,* and to know that the exhibition's tour will bring this important topic to the attention of many viewers throughout the United States. We are proud that this major traveling exhibition, the first critical examination of the impact of the Vietnam War on American art of the past twenty-five years, travels under ICI's auspices. John Olbrantz, Deputy Director of the Whatcom Museum of History and Art, and guest curator Lucy Lippard have organized a strong and provocative exhibition. They have provided us with a unique opportunity to view artworks that are both esthetically and politically powerful, and to reassess the impact of the Vietnam War on our society through a consideration of the diverse viewpoints of the artists included in the show.

I would like to thank John Olbrantz and his staff for their patience and goodwill in working with ICI. We owe Lucy Lippard our gratitude for her curatorial research and essay.

The organization and circulation of each exhibition require many skills and the combined knowledge of ICI's entire staff—Judith Olch Richards, Donna Harkavy, Jack Coyle, Judy Gluck Steinberg, Mary LaVigne, and Andrew Levy. In this instance, I am particularly grateful to Judith Olch Richards, Donna Harkavy, Jack Coyle, and Judy Gluck Steinberg, and former staff member Lise Holst, for their supervision of this project.

Once again, I send an accolade to ICI's dedicated Board of Trustees for its commitment to adventurous exhibitions and its keen support of all our projects.

Susan Sollins
Executive Director
Independent Curators Incorporated

INTRODUCTION

Each soldier has a different war.
—Tim O'Brien, *Going after Cacciato*.

It wasn't even a war. A plain stone memorial in Stamford, Connecticut, lists the Revolutionary War, the Civil War, the War of 1870, and so forth. Then come "The Korean Conflict" and "The Vietnam Era." No such euphemisms are possible today. More than 58,000 Americans, 2,000,000 Vietnamese, 200,000 Cambodians, and 100,000 Laotians were killed. Whatever the history books call it, we know it was a war.

But it was indeed a different war. Politically, militarily, and in its outcome, Vietnam did not resemble what we learned in high school about America's other wars. In Vietnam the U.S. triumphed over no evil empires, and the Southeast Asian adventure might have been virtually ignored as yet another in a long series of imperial incursions against indigenous peoples and Third-World countries. With the government and the military both busily manufacturing disinformation, the truth about Vietnam might never have emerged were it not for a grassroots antiwar movement— "the war at home," which led GIs and vets to speak out as well.

This too made it a different war. Back here, in what the GIs called "The World," even the enemies were different. There were two wars at home: one between the hawks and doves within the establishment, and one between the counterculture and the centers of power. All of these differences affected the art made about the war. When we think about Vietnam and art, we think first of protest art. It was the first war during which there was more art opposing the government than supporting it. Within the isolated art world itself, there were other divisions: between

those artists who felt art should remain untouched by social issues, and those who felt artists should enter the fray. The latter split—again—between those who felt artists should protest in or outside of their artwork.

And this was the first war we were force-fed through The Tube, which had, then as now, its own version of the truth. The staging of the war in our living rooms did not guarantee any less bias or more realism than any other selected (i.e., censored) versions. If anything, television may have made the Vietnam War still less real than other wars, seen as it was, full-color but small-scale, wedged between the dominant culture's other fictions, competing with war movies and sitcoms and the government's ideological offerings. Artists were particularly susceptible to the visual power of war images on TV. Yet only the best-informed were able to sift out the real news between the dots and lines.

It was a different war "in country," for Americans in Vietnam—different in the cities, in the villages, in the field, and at the rear; different in a helicopter, in an F-4, and in a B-52; different in the Delta, in the Highlands, in the DMZ, in Laos and Cambodia; different on the rivers, in the mud, in the hospitals. Some soldiers never even saw Saigon. Outside of photojournalists and a few hired "war artists" who dutifully illustrated patriotic clichés—the few elements this war did have in common with others—images were being stored away in the heads and hands of survivors, to burst forth a decade later. Few combatants, even those already trained or considering careers as artists, made art on site. Of those who did,

many preferred to sketch the landscape and its people, reaching for those few beauties to be found in the midst of such ugliness.

It was a different war for women—the several thousand American women in Vietnam, the millions at home, and the millions of Vietnamese women. For those in Vietnam, it was a question of survival; for those at home in the U.S., it was a choice between conditioned passivity ("it's men's business") and activism—an activism that eventually extended beyond peace to our own liberation movement.

It was a different war for people of color, who were drafted (and enlisted) in disproportionate numbers, as their white middle- and upper-class counterparts got college or medical deferments, or left the country in protest. Minorities bore the brunt of combat—serving in lower ranks, mainly in the infantry, suffering race and class oppression as well as the terrors of battle. Many came to identify more with the Vietnamese "enemy" than with the culture they were sent to protect.

It was a different war for those who refused to go, for the conscientious objectors, for those who fled to Canada or went underground as fugitives, for those who went to jail, and for the courageous few who resisted within the military and found themselves suspect on all sides.

It is—present tense intentional—a different war in its physical and emotional aftermath here and in Vietnam. For the Vietnamese still dying from exposure to toxic chemicals and unexploded ordnance left behind. For the Vietnamese and Americans still dying from Agent Orange absorbed two decades ago. For refugees. For those boat people who survived, and for those who did not. And for those who relocated and are still struggling to adjust to foreign cultures.

It was a different war for the invading Westerners and for the Vietnamese defending their country. In Vietnam the war even has a different name: "The American War of Aggression."

Finally, it is a different war today than it was twenty years ago, for those who cannot forget it, whether they were in Vietnam or not; for those who cannot remember it because they were too young; and for those of all ages who look at Vietnam through the lens of current events in Central America, who remember that it was the U.S. Marines landing in the Dominican Republic in 1965, less than a year after the government-orchestrated Tonkin Gulf incident, that forced the Vietnam intervention into public consciousness.

"SORRY ABOUT THAT"[1]

IN "THE WORLD"

If World War II was like *Catch 22*, this war will be like *Naked Lunch* ... the first open expression of a totalitarian Leviathan which will yet dominate everything still not nailed down in American life: art, civil rights, student rebellions, public criticism in mass media.
—Norman Mailer, 1965.[2]

Two open-letter advertisements in the *New York Times* on April 18 and June 2, 1965, brought the war in Vietnam to the attention of the art community. They were published by a New York group called Artists and Writers Protest, which included Rudolf Baranik, Leon Golub, Nancy Spero, and May Stevens. (The group had already, in 1962, published a letter on nuclear testing, which began, loftily, "We artists of the United States are divided in many ways, artistically and ideologically, but we are as one in our concern for Humanity.") The June 1965 letter was headlined "End Your Silence." It focused on U.S. intervention in Vietnam and the Dominican Republic, ending, "American artists wish once more to have faith in the United States of America. We will not remain silent in the face of our country's shame." By 1968, the language in another letter had become testier and more identifiable with what we have come to see as the interconnected issues of the '60s. Headed "STOP THE DAMNED KILLING! STOP THE TWO WARS!" it attacked racism, the death of Martin Luther King, Jr., and the persecution of Blacks and of antiwar activists like Dr. Benjamin Spock and Mitchell Goodman, as well as the war.[3]

Simultaneously, a Los Angeles group called The Artists Protest Committee was demonstrating in front of museums and closed down the galleries in a "whiteout." On June 26, 1965, they picketed the Rand Corporation, a government-backed

think tank, "to protest Rand's involvement with American foreign policy in Vietnam and the Dominican Republic." They argued with Rand people for some five hours and then suggested a "public dialogue" with corporation executives, which Rand unwisely accepted. The formal debate was held August 3, at the Warner Playhouse. On one side were painters Irving Petlin and Leon Golub and critic Max Kozloff, and on the other side were Rand staff members, including Southeast Asia specialists and political scientists from the White House and Yale University. To many, it appeared that the small but intense and extremely well-informed artists' group came out on top. Rand executives were reportedly instructed never to get into such a spot again.

The other major West Coast event in these early years of protest was the *Peace Tower* (fig.1). Also organized by the Artists Protest Committee, it was raised on a rented vacant lot at the corner of Sunset and La Cienega Boulevards in downtown Los Angeles, in 1966. It was projected to stand "from February 26 until the End of War in Vietnam," but the piece came down a lot sooner when the landlord, under pressure, reneged. The 60' tower was designed by sculptor Mark di Suvero and built with sculptor Mel Edwards and others. It was covered with 400 uniformly sized small panels sent by artists from all over the world. Opening day was heralded by an advertisement in the *New York Times* and opening

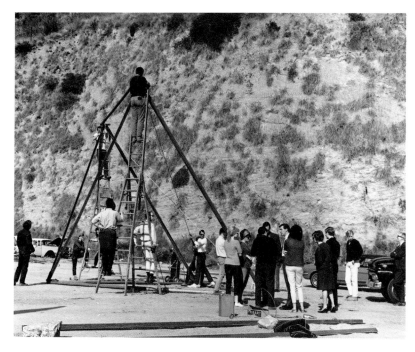

Fig. 1. *Peace Tower* under construction, Los Angeles, 1966.

speeches by Petlin, Susan Sontag, and ex-Green Beret Donald Duncan. Duncan made a crucial distinction: "I am not here today to protest our boys in Vietnam. I'm here to protest our boys being in Vietnam."[4] Participating artists crossed styles and generations, including Philip Evergood, Moses and Raphael Soyer, Alice Neel, Robert Motherwell, Louise Nevelson, Ad Reinhardt, Jim Rosenquist, June Leaf, Philip Pearlstein, Don Judd, Michelle Stuart, Eva Hesse, Arnold Mesches, Judy Chicago, Lloyd Hamrol, and Eric Orr.

In New York, Artists and Writers Protest organized the largest cultural protest event since the '40s. Angry Arts Week, from January 29 to February 5, 1967, was a huge series of dance, music, film, art, poetry, and photography events in which some 600 artists took part (fig. 2). It received good publicity and helped spark the broader artists' movement against the war in the next two years. Illustrious (and motley) sponsors included Judy Collins, Phil Ochs, Yvonne Rainer, Donald Barthelme, Robert Creeley, Paul Goodman, Grace Paley, Nat Hentoff, and Philip Roth. Among its most memorable components were poets' street caravans, midnight postering brigades, a conductorless performance of Beethoven's *Eroica* at Town Hall ("to symbolize the individual's responsibility for the brutality in Vietnam"), and *The Collage of Indignation* organized by critics Dore Ashton and Max Kozloff at New York University's Loeb Student Center.

The 10' × 120' *Collage* was a 150-artist collaboration, painted over a five-day period (fig. 3). Participants included Antonio Frasconi, Roberto Matta, Nancy Graves, Richard Serra, and George Sugarman. Max Kozloff called it "a wailing wall, alienated and homeless in style, embattled in content."[5] Mark di Suvero showed a slab of rusty metal with the torch-cut words "Johnson is a Murderer—In Memory of the Women and Children Killed by Bombs in Vietnam," words he also used on a print in a benefit portfolio. Much of the *Collage* consisted of such outraged expressionist gestures, but some were humorous or subtle. Nancy Graves's camel was labeled "Hump War"; Michelle Stuart's panel was a simply outlined envelope bordered in black for mourning; Jim Rosenquist contributed a coil of barbed wire, a frequent motif in his work at the time (fig. 4); and Fraser Dougherty offered his draft card.

Leon Golub wrote of the *Collage*:

Today art is largely autonomous and concerned with perfectibility. Anger cannot easily burst through such channels. Disaffection explodes as caricature, ugliness, or insult and defamation. . . . This is not political art, but rather a popular expression of popular revulsion. . . . There is refined and subtle protest on the *Collage*, but essentially the work is angry—against the war, against the bombing, against President Johnson, etc. The *Collage* is gross, vulgar, clumsy, ugly![6]

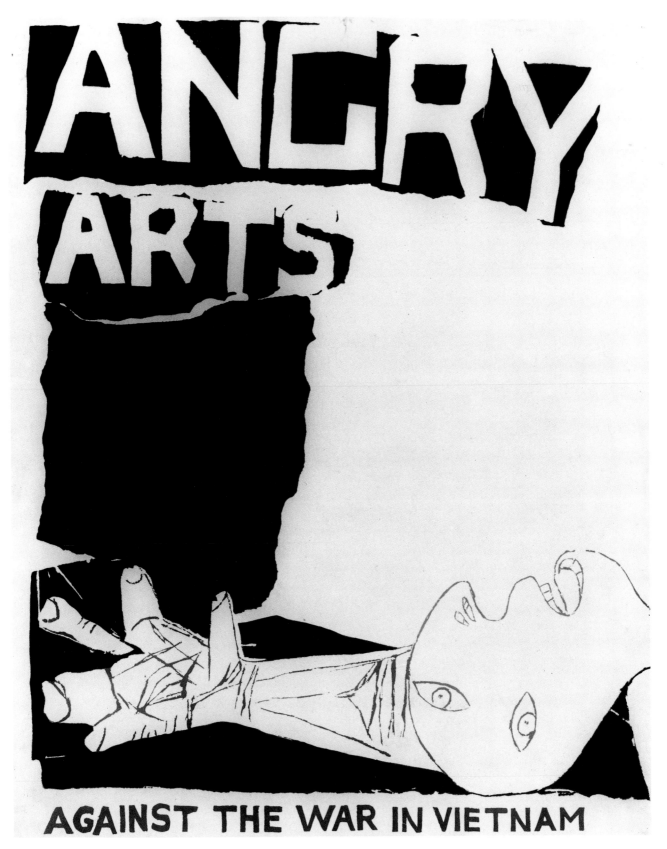

Fig. 2. Rudolf Baranik, *Angry Arts*, 1967, offset lithograph, 21 1/4 × 17 1/4",
collection of the Artists' Poster Committee, New York.

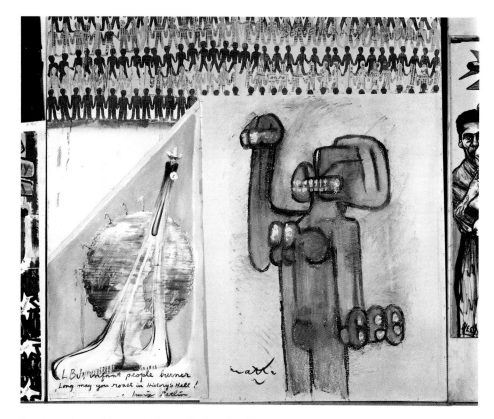

Fig. 3. Roberto Matta and Irving Petlin, detail,
The Collage of Indignation, New York, 1967.

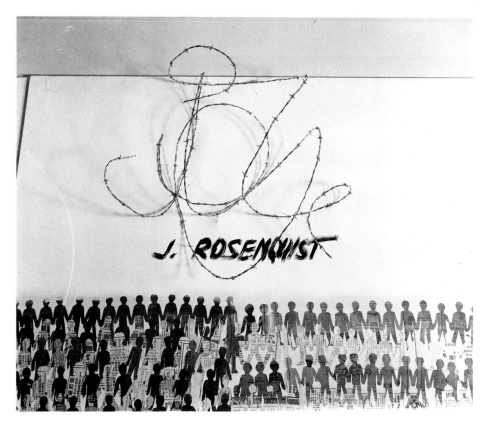

Fig. 4. James Rosenquist, detail, *The Collage of Indignation*,
New York, 1967.

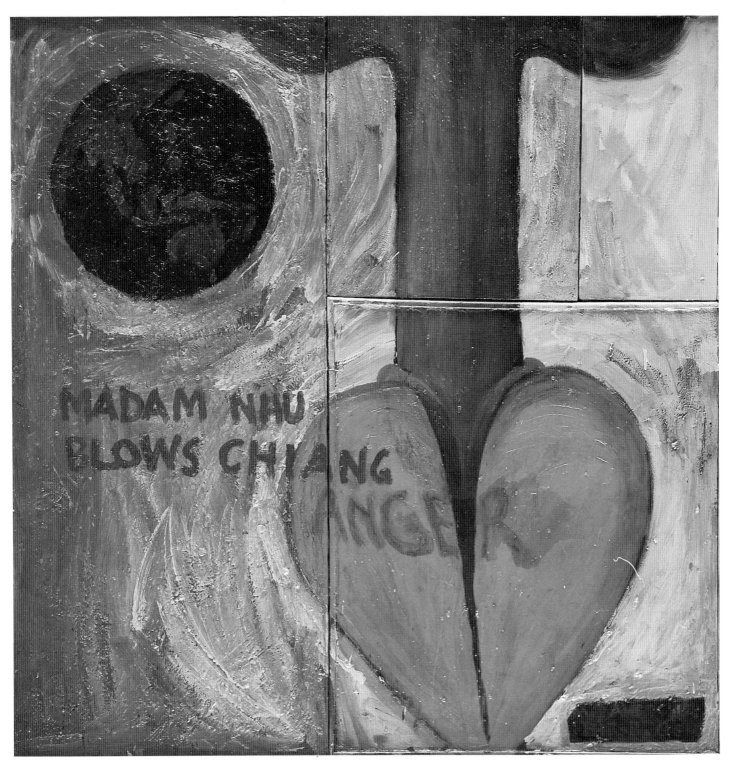

Fig. 5. Wally Hedrick, *Anger/Madam Nhu's Bar-B-Q*,
1959 (cat. no. 51).

Golub's distinctions are important. Art in 1967 was safely ensconced in its own world, primarily concerned with its own physical properties. The scene was dominated by Pop and Minimal art, with kinetic and abstract art highly visible as well. Process and Conceptual art were just beginning to surface. Even realist art rarely touched on social issues, and when it did, it was rarely shown or written about. The older New York artists harbored taboos against social content inherited from the days of Stalinism and McCarthyism, and the younger artists were unaware that art *could* be politically effective. They had been trained to understand that all political art was corny and old-fashioned—barely art in the highest sense—and few had the political sophistication to combat these dominant views.

There were, of course, exceptions. Californian Wally Hedrick was among the first to respond seriously to the Vietnam War in his art. A Korean vet, he became aware of the troubles simmering in Vietnam under the French (supported by the U.S.) while he was a student at the California School of Fine Arts (later renamed the San Francisco Art Institute). In the late '50s he made *Anger/Madam Nhu's Bar-B-Q* (fig. 5). It referred to the self-immolation of Buddhist monks as well as to the simultaneous backing by the U.S. of both Diem's and Chiang Kai-Chek's regimes. A black sun with a brown penis inserted in a red vagina (readable as heart and mushroom cloud), and inscribed "Madam Nhu Blows Chiang" and "Anger," the painting was an explicit message totally out of sync with the prevailing cold-war refinements, much closer in style and effect to the

expressions of sheer rage that pervaded the art world more than a decade later, especially the sexual grotesqueries of Peter Saul.

Hedrick did not stop there. From 1960 to 1970 most of his work consisted of a series of canvases painted out in three different tar-like blacks to convey "the withdrawal of his services from mankind." In 1971 he constructed a black room from eight of these paintings, showing how the U.S. had "boxed itself in" in Vietnam, and in 1973 the whole "Vietnam" series was shown in San Francisco. The announcement was a political broadside demanding, "Why Should Something Exist Rather than Nothing? (Subtitled Youth-in-Asia)." The paintings themselves were called "refugees," "MIAs," "war orphans," or "wounded veterans" (these were damaged paintings), and Hedrick encouraged their "adoption."

Another artist active in the early '60s protesting the war also produced black paintings. Ad Reinhardt—the "Black Monk" and self-appointed watchdog or conscience of the art world—would never attach any referential title to his obdurately non-objective abstractions. His art-as-art-and-nothing-else position had, however, never excluded political action. "Painting cannot be the only activity of a mature artist," he said. "Do you think that when a painter expresses an opinion on political beliefs he makes even more of a fool of himself than when a politician expresses an opinion on art?" he asked rhetorically in 1946, and answered himself with a resounding "NO!"[7]

Reinhardt did make one political work, entitled *No War* (fig. 6), produced in 1967 as a print/poster for an Artists and Writers Protest

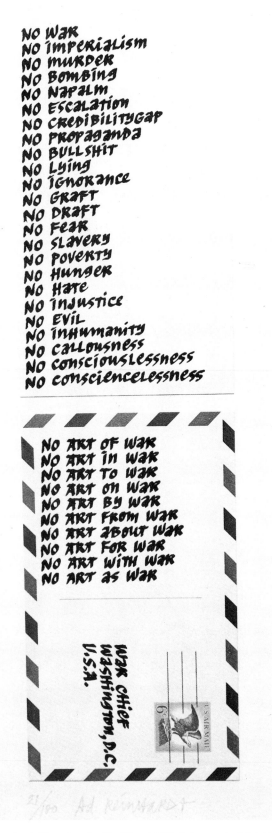

Fig. 6. Ad Reinhardt, *No War*, 1967, lithograph, 26 1/4 × 21 1/4", private collection, New York.

portfolio. It is a double airmail postcard addressed to "War Chief, Washington, D.C., USA." Carefully handprinted in Gothic script is one of his classic negative lists:

No war, No imperialism, No murder, No bombing . . . No consciencelessness.

And on the other side:

No Art of War, No Art in War, No Art to War, No Art on War, No Art by War, No Art from War, No Art about War, No Art for War, No Art with War, No Art as War.

Reinhardt's position was a model for socially conscious abstract artists who chose not to change their art but at times assigned a slightly different function or title to it (e.g., Frank Stella's resurrection of one of his black pinstriped paintings for an Attica poster in 1974). Occasionally they made an object like Reinhardt's postcard that was seen strictly as "propaganda" and bore no relation to their normal, stylistically recognizable work (e.g., Dan Flavin's poster for George McGovern captioned simply, and naively, "I Believe Him," or Andy Warhol's more subtle McGovern poster, which consisted of a portrait of Nixon). The majority of abstract artists made no direct connections but were moved to donate works to the endless stream of benefit exhibitions for antiwar groups or Vietnamese relief.

In the fall of 1968 peace activist Ron Wolin and Minimal painter Robert Huot thought it was time the art world offered another major response to the war, continuing the momentum of Angry Arts Week the previous year. They asked me to join them, and we put together an exhibition to open the new Paula Cooper Gallery in SoHo as a benefit for the Student Mobilization Against the War. A striking show of major Minimal art whose content had absolutely nothing to do with the war, it included Robert Ryman, Robert Morris, Jo Baer, Don Judd, Carl Andre, and Sol LeWitt's first publicly installed wall drawing. A cool, monumental, and powerful group, it earned some $30,000 for the cause. The organizers' statement offered the abstract artist's rationale:

These 14 non-objective artists are against the war in Vietnam. They are supporting this

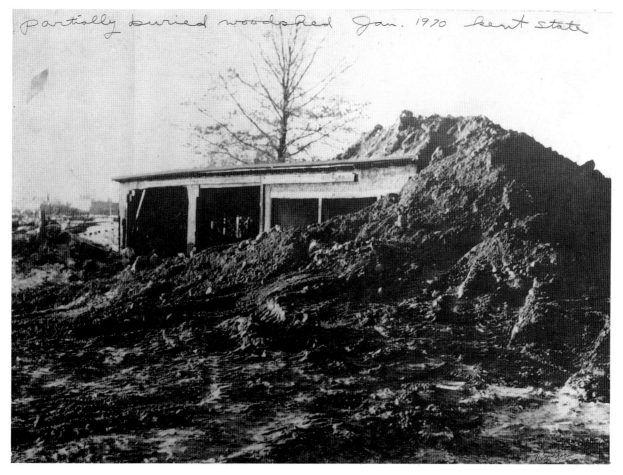

partially buried woodshed Jan. 1970 Kent State

Fig. 7. Robert Smithson, *Kent State*, 1970, offset lithograph, 22 × 30",
collection of the Committee for the Collage of Indignation II, New York.

commitment in the strongest manner open to them by contributing major examples of their current work. The artists and the individual pieces were selected to present a particular esthetic attitude, in the conviction that a cohesive group of important works makes the most forceful statement for peace.

Even the best-intentioned artists were literally disarmed by the prevailing radical credo that only direct action was effective. Robert Smithson expressed their bafflement as to how to proceed when the '60s caught up to them:

> The artist does not have to will a response to the deepening political crisis in America. Sooner or later the artist is implicated and/or devoured by politics without even trying. . . . If there's an original curse, then politics has something to do with it.[8]

Smithson's only "political" work came about by accident. Asked to do a piece at Kent State University in 1968, he found an abandoned woodshed on campus and piled it up with dirt into an ambiguous grave-ruin. Soon it had become hideously prophetic, when the National Guard opened fire on an antiwar demonstration and killed four participants. At that point Smithson's piece became a "monument," and a photograph of it was exhibited as an antiwar poster (fig. 7).

The Art Workers Coalition (AWC), the most active artists' group against the war, was formed in January 1969, not in response to global politics but to the Museum of Modern Art—the Big Daddy in the home sector universally known as MoMA.

The group formed to support Kinetic artist Takis Vassilakis's right to remove from MoMA's "Machine" show a work he felt did not properly represent him because it was too small and too old. That a kineticist should be so instrumental in bringing together art and politics was appropriate; in New York, most of the better-known kineticists were from Europe or Latin America and tended to be politically more sophisticated than North Americans. Wen-Ying Tsai, Len Lye, and Hans Haacke, all of whom showed at the Howard Wise Gallery, were active in the AWC.

Connections were rapidly made between artists' rights and human rights in general, between the corporate profits made from war and the fact that those running the major art institutions were also leading the "military industrial complex." As Gregory Battcock bluntly put it, "Do you realize that it is those art-loving, culturally-committed museum trustees of the Metropolitan and Modern museums who are waging the war in Vietnam?"[9] The fact that the museums were inactive and unresponsive to demands that they take positions—on war, on racism, and later on sexism—triggered sometimes irrational anger, but also sparked the questions that needed to be asked about the role of museums and the place of artists in the power structures built upon their art.

Given the '60s emphasis on life-style and liberated creativity—Doing Your Own Thing—artists were for the first time in a long time considered potential leaders in the "real world," or at least in the counterculture. They were supposed to be the freest of us all. Yet, in fact, the radicalization of a small sector of the art community led

many artists to explore their own socially-conditioned prisons—to see how far esthetic freedom stretched, how much of it was illusory, and even how much their esthetics were determined by the institutions that decided their fates.

Even as the art community began to have access to first-hand testimony from the increasingly disillusioned GIs, even as we began to march and hold benefits for the resistance, as we watched draft cards burned in Central Park, saw friends disappear underground or flee to Canada and saw 9,500 arrested at the 1971 May Day protest in Washington, as we listened to the Winter Soldiers testify at the Vietnam Veterans Against the War (VVAW) hearings on Vietnam war crimes, watched over 1,000 veterans hurl their medals onto the Capitol steps, and learned of the 200 GI antiwar newspapers and the USSF Coffee House movement for dissent among the armed forces— artists still failed to internalize these events, for they remained largely invisible in the actual art objects. The images most remembered from the war are, with few exceptions, not those created by professional "fine artists"—a category that excludes illustrators, cartoonists, poster makers, et al.

Australian artist Ian Burn, then living in New York, has observed that artists working in official art-world-sanctioned styles in the late '60s found these styles useless for any kind of social protest:

> In other words, the artists' major means was voiceless, incapable of conveying their rage at the United States' involvement in Vietnam . . . The belief that art naturally and rightly

"transcended" such issues was still widely and strongly held.[10]

While MoMA (and later all other New York museums) remained a target, the AWC evolved rapidly into a vehement learn-while-you-act consciousness raising arena for artists (and all artworkers; this is where I received my own political education). At early meetings, there were esthetic/stylistic divisions among members, but these were eventually rearranged into ideological camps, with a unique brand of leftish anarchism dominating. The membership itself was open, flexible, and constantly in flux, with an active hard core, many of whom were in the most militant and imaginative arm—the Action Committee—which was allowed the utmost freedom to act, since it was agreed that no one committee could veto another.

The AWC never claimed to represent all artists:

> Our actions should not be mistaken for those of the community as a whole, but rather as a "conscience" in regard to the existing system. We represent the present membership and, by default, the passive element in the art community. . . . Anyone who does not speak for himself will be spoken for by us until he [sic] does take a position on the various issues.[11]

On January 28, 1969, after Takis had removed his work from the "Machine" show without MoMA's permission and after a follow-up support rally had been held, the AWC presented a list of "13 Demands" to the museum's director. It included an artists' registry, a Black and Latino

section in the museum, an artists' curatorial committee, two free evenings a week for working people, rental fees to artists for exhibited works, environmental shows outside the museum's premises (and sometimes in Black, Puerto Rican, and poor white neighborhoods), regard for copyright and artists' grievances, and a public hearing at MoMA concerning "The Museum's Relationship to Artists, and to Society."

The museum declined to hold the hearing after demonstrations there, and it took place instead at the School of Visual Arts on April 10, 1969. It was a truly historic occasion. The auditorium was packed. Some seventy speakers held forth on various topics more and less related to museums. There was a strong anti-racist representation by Black and Puerto Rican artists. The war in Vietnam, curiously, was mentioned by only a few people, although it provided the invisible context for the whole event. As Jean Toche of the Guerrilla Art Action Group said, "To fight for control of the museums is also to be against the war." And critic Gene Swenson articulated the general tone when he said, "Art cannot flourish in a time of war and exaggerated tensions . . . in esthetic theories which detach the spirit of the times from the events."[12]

Carl Andre was one of the most active members of the Art Workers Coalition and one of the few members who had actually studied Marx. He was also at the peak of his early career as a Minimal artist—a fact that worked both for and against him as he articulated his grievances against the hand that fed him and raised the general question of class interests. Attributing his politicization to students' questions when he lectured in the U.S. and abroad, Andre had a show at the prestigious Dwan Gallery in 1969 in which he demonstrated the connections between abstraction and politics, pointing out a way, à la Reinhardt, that artists could politicize themselves rather than their art. His modular, Minimal sculptures were constructed entirely from rusted units ("particles") found in the streets or on construction sites. He offered them for sale for 1 percent of the buyer's annual income, thus making it possible for his fellow artists to afford the works, while many collectors could not.

He called this work "materialist" and was often an articulate spokesperson for the AWC, as when he told an interviewer in 1970:

> The war in Vietnam is not a war for resources, it is a demonstration to the people of the world that they had better not wish to change things radically because if they do, the United States will send an occupying, punishing force. . . . And they wish to run these quiet apolitical institutions like museums and universities suppressing politics among artists, among students, among professors. . . . We are killing people ostensibly to maintain the rationale of artistic freedom.[13]

Mark di Suvero was another abstract artist who was mightily opposed to the war, but he expressed it primarily outside of his work. He finally moved to Europe in 1970 as a protest against U.S. involvement in Vietnam. Several of his sculptures from the late '60s referred by title to the war, such as *Flower Power* (1967), *Mother Peace* (1970), and *Homage to the Viet Cong* (1971). *Mother Peace* (fig. 8), a stern and graceful series of steel vortices now at the Storm King Art Center, still bears the peace symbol painted on one of its elements, but the Viet Cong title has been changed, and there remains no trace of

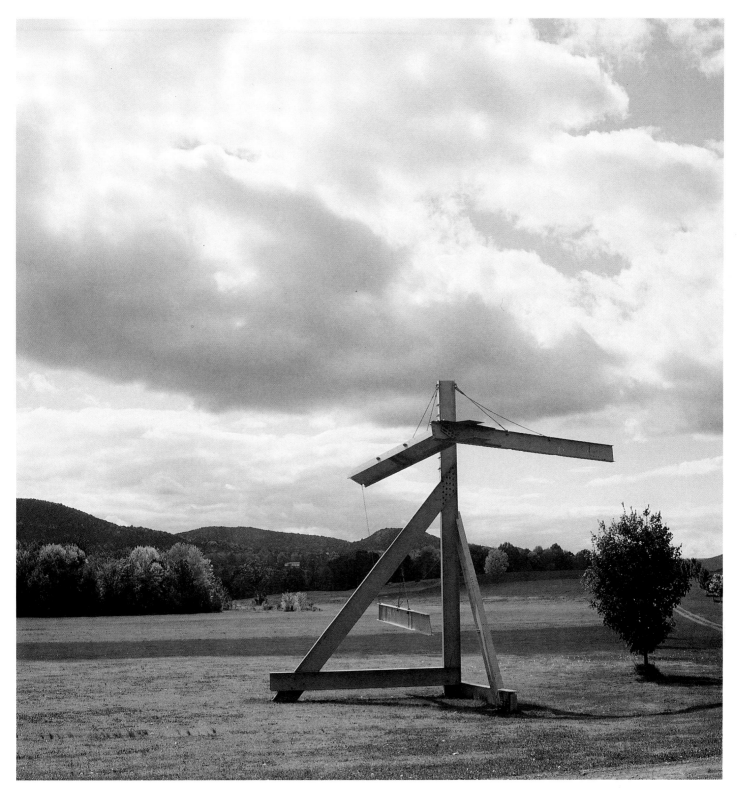

Fig. 8. Mark di Suvero, *Mother Peace*, 1970, painted steel, 474 × 461 × 392 1/2",
collection of the Storm King Art Center, Mountainville, New York, gift of The Ralph
E. Ogden Foundation and by exchange.

another piece installed in Central Park (and reproduced in *Newsweek*) that was inscribed "LBJ is a Murderer."

With Artists and Writers Protest, the AWC produced several inventive antiwar actions. On April 2, 1969, a "Mass Antiwar Mail-In" addressed to "The Joint Chiefs of War" consisted of mailable artworks taken, in procession, to the Canal Street Post Office, where we solemnly stood in line and displayed our "packages"—among them a papier mâché bomb—as we mailed them to Washington. In one moving and effective demonstration piece, we carried black body bags (exactly the kind used in Vietnam, hunted down by Irving Petlin) marked with the number of American and Vietnamese dead, whose names were written on white cloth runners, over a block long, flanking the procession. People threw flowers on the bags; even the police, recognizing names, were respectful.

For the big Moratorium march on Washington on November 15, 1969, after the My Lai massacre became public, we manufactured thousands of photographic masks of Lieutenant William Calley. The idea was that everyone shared responsibility for the atrocities committed by our troops in Vietnam, but some interpreted it as support for Calley, and a lesson was learned about the transferral of esthetic ambiguity into the streets. At another point, the AWC sent out a humorously intended postcard invitation to a meeting to discuss "plans to kidnap Kissinger," and the FBI showed up.

For the duration of the war, any number of "actions," "events," "happenings," "guerrilla theatre," and "street works" took place across the country, often indistinguishable from non-art activities. In New York, for instance, a 1967 performance series at the Judson Church included Lil Picard's *Peaceobject*, in which she burned "the mass media message of endless, infernal warfare, into ashes of purity." Kate Millett caged much of her audience and referred obliquely to the 1967 March on the Pentagon. Composer Malcolm Goldstein's *State of the Nation* was "performed by Lyndon B. Johnson and You (the public)" and featured a recorded speech on Vietnam which the audience cut up and rearranged, transforming "sense" ("We are involved in Vietnam because it is our deep conviction that it is essential to American security to prevent aggression from gaining momentum in Asia") into music, or "non-sense." Carolee Schneemann's *Divisions and Rubble* (fig. 9) was a heap of refuse, one wall collaged with a large, torn LBJ image and Vietnam photos that people were invited to smear with paint, hammer with nails, or cut with scissors. She intended to contrast the wasteful society of the U.S. with "a rural agricultural ancient delicate organically balanced society which has no garbage [like Vietnam] . . . EAT WHAT YOU KILL, yeah."

The most consistent and enduring series of public actions by artists was the work of the Guerrilla Art Action Group (GAAG), which was sometimes part of and sometimes separate from the AWC. GAAG focused on, but was never limited to, the war, and it continued, sporadically, into the '80s. The "group" was mainly two young artists—Jon Hendricks and Jean Toche—but Poppy Johnson was a member for their most

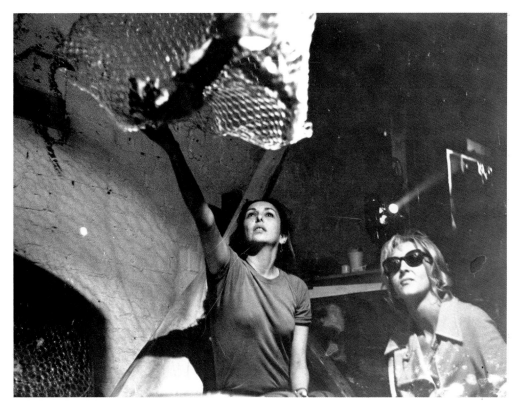

Fig. 9. Carolee Schneemann's *Divisions and Rubble* performance
at the Judson Memorial Church, New York, 1967.

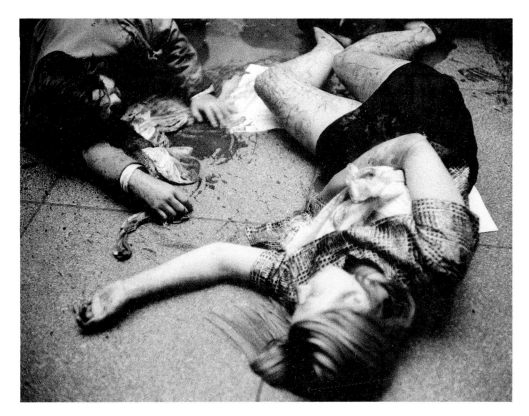

Fig.10. Guerrilla Art Action Group's "Blood Bath" demonstration at
the Museum of Modern Art, New York, 1969. See Appendix, p. 123,
for GAAG's November 1969 communiqués.

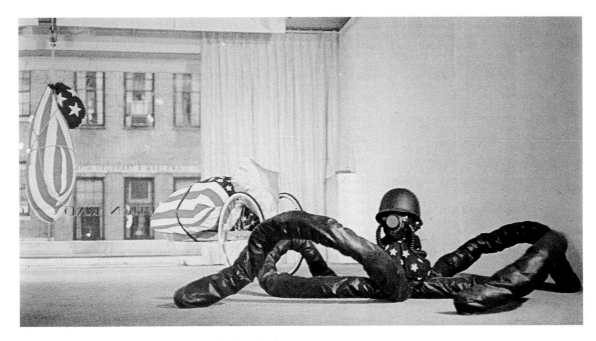

Fig. 11. Marc Morrel exhibition at the Stephen Radich Gallery, New York, 1966.

notable first year, and Silvianna joined them now and then. Although physically unable to participate in the actions, Virginia Toche was also an integral member of the group. Jan van Raay faithfully documented all their interventions and became the unofficial AWC photographer.

Influenced by Dada, Fluxus, Destruction Art, and Happenings, Hendricks and Toche performed unannounced public pieces, often in and around New York museums. In October 1969 they entered the Museum of Modern Art, gently displaced Malevich's *White on White*—the "revolutionary" masterpiece—and replaced it with a manifesto about poverty, war, and the role of art:

> There is no justification for the enjoyment of art while we are involved in the mass murder of people. Today the museum serves not so much as an enlightening educational experience, as it does as a diversion from the realities of war and social crisis.

GAAG declared that art should be produced during such crises but that its "sanctification" should cease. In November 1969 the group performed actions at the Museum of Modern Art (fig. 10) and the Whitney Museum of American Art. Entering the museums, they would suddenly drop a pile of their written demands on the floor, and begin to rip at each others' clothes, crying "Rape!," bursting sacks of concealed animal blood, and sinking to the ground, moaning. When they rose, the crowds applauded as for a theater piece. GAAG would then ask the audience to "help us clean up this mess"; given the climate of the time, most of the spectators probably understood the intended reference to Vietnam.

Hendricks and Toche were among the organizers of the art world's most exuberantly productive response to the war after Angry Arts Week. "The People's Flag Show" opened at Judson Memorial Church on November 9, 1970, following a sermon by the Reverend Howard Moody, called "Symbols and Fetishes; a Left-Handed Salute to the Flag," and an inaugural flag-burning by GAAG. The show was intended as "a challenge to the repressive laws governing so-called flag desecration, which was already the subject of a famous case involving the sculptor Marc Morrel, an ex-Marine whose one-man show (fig. 11) had caused the arrest and conviction of his dealer, Stephen Radich, and paved the way for a federal flag desecration bill in June 1967.[14] "A flag which does not belong to the people to do as they see fit should be burned and forgotten," stated the Judson poster. "If the flag can be used to sanctify killing, it should be available to the people to stop killing."

This was a classic artist's issue, involving as it did both freedom of expression and an image inextricably associated with the war. Supporters waved the flag and protesters insulted it. The flag was a staple of antiwar posters and art, its stars

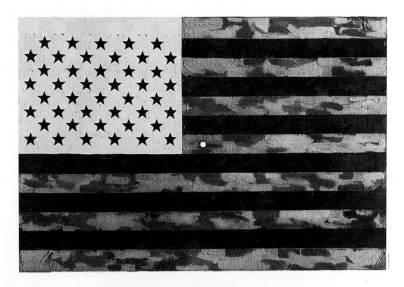

MORATORIUM

Fig. 12. Jasper Johns, *Moratorium*, 1969, offset lithograph, 22 1/2 × 29",
collection of the Artists' Poster Committee, New York.

and stripes reduced to guns, bombs, coffins, skulls, prison bars, and so forth. Detectives from the Mayor's office were stationed outside the church when the Judson Flag Show opened ("to protect the people"). Inside, Yvonne Rainer, David Gordon, and others from the dance troupe Grand Union performed a nude dance with flags. Three members of the organizing committee were arrested, and the church was closed (though it opened the next day in defiance of the D.A.'s orders, and the show remained open).

Thus Hendricks, Toche, and Faith Ringgold became the Judson Three. They were tried and convicted, losing an appeal as well, despite legal defense by the ACLU and protests in Europe as well as in the U.S.[15] In the process, a member of the court suggested that visual art was not really a "form of communication" (an opinion shared, alas, by many artists) and was therefore not protected by the First Amendment. But sculpture seemed particularly threatening, and more subversive than two-dimensional images. Sculpture, proclaimed Assistant D.A. Gerald Slater, "can be touched, it can be seen, and it is an object more likely to arouse public wrath." This may explain why Jasper Johns's 1969 *Moratorium* poster (fig. 12)—black stars and stripes on an orange and green field—a small white bullet-hole notwithstanding, attracted no legal attention. (The colors produced a red, white, and blue afterimage; he might have been "quoting" a poem by Soviet poet

Yevtushenko: "The stars/in your flag America/are like bullet holes.") Within the art world, Johns's was a particularly subtle and impressive statement, coming as it did from a highly respected artist who had, after all, made the American flag into art with his paintings from the late '50s.

Whether or not posters open hitherto closed minds, they play an important role in their visibility, expressing information and resistance omitted from the mass media. Like graffiti, they name cultural identities and political positions disbarred elsewhere—until they are perceived as co-optable and no longer threatening, at which point the dominant culture welcomes and patronizes them as quaint, "merely cultural" manifestations. The split between "gallery art" and poster art can be seen as a class division, given their very different, if sometimes overlapping, audiences. During the Vietnam war, even the Pop artists rarely ventured into the poster field except with more expensive limited editions and "multiples," though Pop appropriations from the commercial sphere had a decided influence on the best commercial poster art. And, as Ralph Shikes has remarked, "unless protest appears on the streets, it is like the unheard sound in the forest."[16]

The only truly successful poster to emerge from the art world was by the AWC's Poster Committee. It used Ronald Haeberle's shocking color photo of the dead from the My Lai (or Song My) massacre, captioned simply "Q: And Babies?

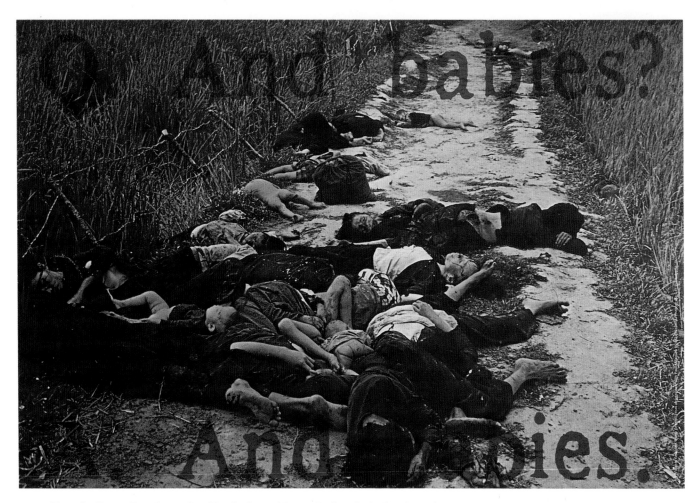

Fig. 13. Fraser Dougherty, Jon Hendricks and Irving Petlin, *Q: And Babies? A: And Babies*, 1970, offset lithograph, 24 × 35 1/2", collection of the Artists' Poster Committee, New York.

A: And Babies" (fig. 13). The words were from a Mike Wallace interview with My Lai participant Paul Meadlo. The poster was an anonymous collaboration by Irving Petlin, Jon Hendricks, and Fraser Dougherty, originally intended to be distributed under the auspices of the Museum of Modern Art, until William Paley, president of the Board of Trustees, vetoed the staff decision. The international artists' community rose to the occasion. Fifty-thousand copies were printed by the lithographers union and distributed all over the world by informal art community networks; they turned up in newspapers and demonstrations for years. A second version was put out when Nixon was running for re-election in 1972, with the caption changed to "Four More Years?"

The success of *And Babies* gave the AWC a sense of self-determination that MoMA's patronage would not have offered. When the poster was turned down, the AWC staged two demonstrations at the museum (fig. 14), using the poster as a sandwich board and staging a tableau (including

artist Joyce Kozloff with her small son) inside the galleries in front of Picasso's *Guernica*. Although there were other My Lai posters (notably *My Lai/We Lie/They Die*, featuring a naked youth sprouting weapons for genitals, posed like gay porn, and sponsored by "The Committee for the Promotion of Selective Youth in Asia"), there were few My Lai images in "high art." Rudolf Baranik, in his later "Napalm Elegies," used the My Lai photo in a work called *American Moonshot*, and Mexican Arnold Belkin did a painting also shown in "A Patriotic Show" at the Lerner Heller Gallery in New York in 1976.

Given the popularity of the poster form, in 1971 Ron Wolin and I put together *The Collage of Indignation II*, commissioning almost one-hundred original poster designs from a diverse group of "high artists," including many who would never again experiment with this form. The results ranged from brilliant to bizarre, but few would have made effective street posters. Carl Andre quoted My Lai scapegoat Lieutenant

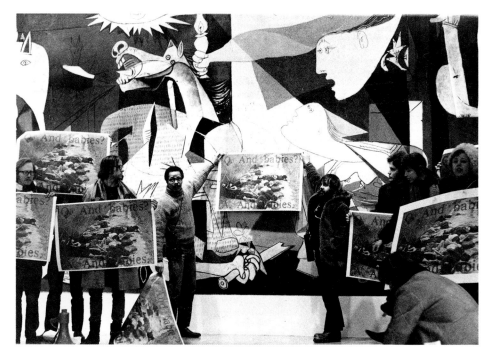

Fig. 14. Art Workers Coalition demonstration at the
Museum of Modern Art, New York, 1970.

Calley, convicted for the murder of "human
orientals": "It was no big deal, Sir"—a statement
borne out by numerous veterans in later years.[17]
Robert Ryman, known for his all-white paintings,
deliberately misspelled "Pease" in pale pencil on a
white field; Alex Katz made a portrait of a worried
boy (my son, who was indeed alarmed by the
demonstrations, and by the grisly images of My
Lai); Susan Hall did a lovely drawing of a figure
in a landscape, *A Woman Dreams of Peace*; Jim
Rosenquist's *Stars Moon Hat and Stripes* was an
oblique play on U.S. "intervention" on the moon;
Faith Ringgold's *Peace America* referred to the
war at home against Black people; Uruguayan
Luis Camnitzer's *Yankee Go Home* paralleled
Latin America and Vietnam; Conceptualist
Douglas Huebler contributed a blank page in-
scribed "Existing Everywhere Ahead of the Above
Surface is Every Reason for Peace"; and several
artists, including Joseph Kosuth, made connec-
tions to the Nazis via Hitler or Nuremberg.

The *Collage* was shown in several venues.
The designs were for sale to benefit the Peace
Action Coalition and Student Mobilization, the
idea being to use the money earned to print cheap
editions of an increasing number of the designs,
and sell them in turn, but the process turned out
to be too expensive, and Robert Rauschenberg's
was the only one to multiply. His piece attempted
to bring the war home to the print's buyers by
leaving a blank square in the center, into which he

asked people to paste a current headline or news
clipping about the war, transforming each print
into a unique and personal work. Few followed
his idea, reluctant to "damage" a valuable com-
modity, or too intimidated to "collaborate" with
a famous artist. Leaving the blank pristine, of
course, negated the whole idea.

The cooperative success but substantive
failure of this grand project was indicative of the
failure of North American artists to confront the
magnitude of the Vietnam disaster. Much of the
antiwar fine art made in the U.S. was strangely
pallid, floundering for ways to come to grips with
a war so totally different. In this respect, artists
were no different from other North Americans;
many could sympathize, but few could empathize.
As Susan Sontag pointed out:

> Most Americans are possessed by a pro-
> found chauvinism that is existential rather
> than ideological; they really do not believe
> that other countries, other ways of life, exist,
> in the way that they and theirs do.[18]

American artists' representations in interna-
tional exhibitions in the late '60s bear this out by
ignoring the war. Perhaps the most famous show
of 1969—at the Kunsthalle in Bern, Switzerland—
was aptly called "Live in Your Head: When Atti-
tudes Become Form." Although a number of the
artists included, such as Hans Haacke, Robert
Morris, Carl Andre, Claes Oldenburg, Lawrence

Weiner, Sol LeWitt, Joseph Kosuth, and Robert Smithson, were more or less involved in antiwar activities, none felt such a showcase an appropriate platform to criticize U.S. policy in Vietnam or to make even the most oblique comment on the situation. This went for art writers as well (including me). Nicolas and Elena Calas published a book in 1971 called *Icons and Images of the Sixties* without a single mention of politics or the war.

The AWC lasted until late 1971, when it faded away under the impact of internal divisions, disagreements about tactics, and the founding of the women's art movement, which siphoned off much of the working energy. Its last major gasp completed the circle, returning to the issue of artists' rights. The Guggenheim Museum canceled Hans Haacke's one-man exhibition because of a "social systems" piece about absentee landlords that appeared to threaten the trustees to the point of total irrationality. The protest included a conga line led by Yvonne Rainer up the museum's spiral ramp, with participants chanting "No More Censorship."

It was also apt that the AWC's last major event was concerned with Conceptual Art, because in some sense Conceptualism was the most "revolutionary" work from 1965 to 1973. It provided an internal, institutional critique, bearing the same relationship to the art of that time as the Free Speech Movement bore to the antiwar movement as a whole. Conceptual art reflected an idealism that began with the tabula rasa of its progenitor, Minimal art. On one level, Conceptual art was as rejective as its progenitor, Minimal art.

Its dismissal of the precious object or commodity, however, led to a renewed acceptiveness. The dematerialized forms—xeroxed photo texts, performances, video, ephemeral installations, and street works—emerged from a very countercultural desire for a democratized (but hardly populist) art, for liberation from traditional art contexts, and for decentralization of the powerful institutions, especially MoMA. These forms were supposed to bring art back into the realm where people lived, worked, and had political impact, but esoteric content guaranteed failure.

It was no accident that Conceptual art forms were preferred when "political art" made its comeback in the mid-'70s and then again in the late '70s and early '80s. Although many of the Conceptual artists were active members of the AWC, their art-conditioning was so internalized that no one really escaped it. Asking themselves why they should add more "precious objects" to a world already glutted with them, asking who they were making art for, and where it should go once it left the studio, the Conceptualists nevertheless stopped short of engagement. There was a certain naive awe in the face of anything "ordinary" as an antidote to the idealization and commodification of high art. Curiosity about almost everything *but* politics was a hallmark of "idea art," suggesting just how deep the McCarthyite dirt lay over the grave of social activism from the forgotten '30s and '40s—a grave still not fully exhumed. Perhaps political subjects seemed too easy. But in retrospect, it would have been simple enough (though not site-specific) for Lawrence Weiner to textually toss rubber balls over the border between

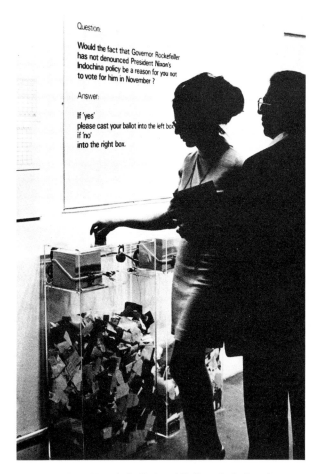

Question:

Would the fact that Governor Rockefeller
has not denounced President Nixon's
Indochina policy be a reason for you not
to vote for him in November?

Answer:

If 'yes'
please cast your ballot into the left box
if 'no'
into the right box.

Fig. 15. Hans Haacke's *Visitors' Poll*, included in the "Information" exhibition at the Museum of Modern Art, New York, 1970.

Vietnam and Cambodia instead of the U.S. and Canada, as in his 1969 boundary pieces (which might, in turn, have been obliquely referring to draft resisters).

Even Hans Haacke, later to become one of the most honored and effective political artists in the "high art" context, was oblique and neutral in his '60s social systems pieces, which included an incessant flow of news from a telex machine in the "Software" show at the Jewish Museum and his *Visitors' Poll* (fig. 15) in the MoMA "Information" show, both in 1970. One of the poll's questions was whether Nelson Rockefeller's chances for re-election were damaged by his silence on Nixon's Vietnam policy; when the piece was shown in Milwaukee in 1971, one of the questions was "Do you think the moral fabric of the U.S. is strengthened or weakened by its involvement in Indochina?" In 1975 Haacke said about "political artists":

> I sympathize . . . but I'm not sure that the way some of them go about it in a rhetorical way is the level at which their targets are operating. If you make protest paintings, you are likely to stay below the sophistication of the apparatus you are attacking. It is emotionally gratifying to point the finger at some atrocity and say this here is the bastard responsible for it. But, in effect, once the work arrives in a public place, it only addresses itself to people who share these feelings and are already convinced. Appeals and condemnations don't make you think.[19]

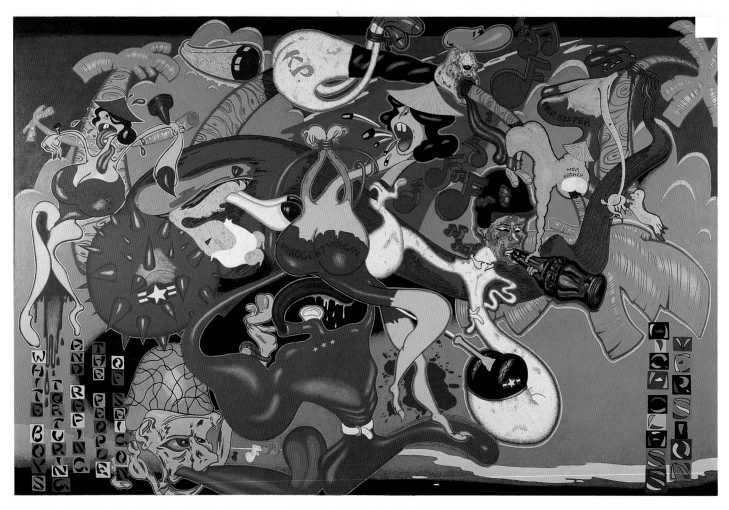

Fig. 16. Peter Saul, *Saigon*, 1967, oil on canvas, 92 3/4 × 142", collection of the Whitney Museum of American Art, New York, purchased with funds from the Friends of the Whitney Museum of American Art.

In 1970, although the Movement itself had begun to wind down, the art world was mobilized on both the esthetic and the political fronts. Artists were stunned by the bombing of Cambodia, the massacre of four students at Kent State, and the less publicized attacks on African-American students at Jackson State College in Mississippi, where two students had been killed and nine wounded a few weeks earlier. The California College of Arts and Crafts' "Poster Factory" churned out over 80,000 posters in two weeks in May.[20] At Stanford and other schools, traveling exhibitions of protest art were set up. Berkeley blew out the stops with graffiti, posters, and murals, and Berkeley's University Art Museum took down a Pol Bury show and held an open exhibition of poster art, hung floor to ceiling.

In New York, on May 18, some 1,500 artists gathered at New York University's Loeb Student Center to plan a concerted reaction to the month's events. Poppy Johnson gave a brief, impassioned speech saying, as she recalls, "since everything

was so terrible, artists had to sort of stop what they were doing and just totally concentrate on doing something else." She and Robert Morris, who announced he would close down his one-man show at the Whitney Museum because of Kent State, were elected co-chairs to head a day's Art Strike—an idea originally proposed by the artists teaching at the School of Visual Arts. Most of the artists in the "Using Walls" exhibition at the Jewish Museum had already voted to withdraw their work.

Irving Petlin, one of the Art Strike's organizers, recalls the meeting as "very vibrant and lively. . . . One of the rare times in fact when you got what you wanted, a mandate to go ahead." Yet it was depressingly obvious to him, as to many participants, that "it takes an event like Kent State or Cambodia or something like that to alert normally sleepy and self-satisfied souls that something is up." Marcia Tucker, then a curator at the Whitney, recalled being "very upset at the fact that a lot of people's public viewpoints at that meeting

Fig. 17. Irving Petlin, *Rubbings from the Calcium Garden: The Fire Children*, 1972 (cat. no. 66).

seemed directed, polemically, toward the art world rather than toward politics," primarily because of the basic political ignorance of most artists. The consensus was that art was useless as a political weapon but it might, as Sean Elwood has observed, "become effective if those who created art objects withdrew those objects from the society they wished to change. The artists had in a sense unionized."[21]

Art Strike sent out letters to New York museums, and a statement was released to the press, promising to forego violence against objects or property. The Whitney circulated a petition, set up Peter Saul's 1967 painting *Saigon* (fig. 16) in the lobby, and closed on May 22, the day of the strike, as did the Jewish Museum and fifty private galleries. The Guggenheim remained open but suspended admissions and removed all the paintings from the walls—a gesture readable in various ways, but apparently motivated by fear of violence. MoMA remained open but charged no admission that day and ran an antiwar film program; Frank Stella closed his one-man show for

the day. Yet MoMA director John Hightower issued a statement to the press accusing the artists of repression, of acting like Hitler and Stalin.

The Metropolitan Museum of Art remained open and was chosen as the site of the day's major protest. Hundreds of artists held white-on-black signs starkly lettered "Art Strike Against Racism, War, Repression" and leafletted the entering public. So did the museum, noting its decision to remain open and allow "art to work its salutary effect on the minds and spirits of all of us." There were a lot of policemen and cameras. Carl Andre cleaned up the Met's act with a broom. Some of the artists remained on the steps for a full twelve hours. In the end, both sides announced they had won.

There was a smaller action in June 1970 at the conference of the American Association of Museums, and artists lobbied Senators Jacob Javits and Claiborne Pell in Washington. Twenty artists withdrew from the summer Venice Biennale "as an act of dissociation from U.S. government sponsorship." Art Strike continued to exist in

name for a while longer but was soon reduced back to the hard core of the AWC, from whence it had come.

On the esthetic front, the events of spring 1970 drastically affected curator Kynaston McShine's "Information" exhibition at the Museum of Modern Art. The show was intended to introduce to the establishment the products of some four years of relatively underground Conceptual art, to document the new art within a "culture that has been considerably altered by communications systems." When it opened in July, however, many of the artists had revised their contributions to express their outrage at the war. The exhibition catalogue was particularly radical: the AWC's *And Babies* poster was reproduced; the endpapers were serial photographs of a vast unidentified demonstration in Washington; and there were fifty pages of uncaptioned photographs making up the body of the catalogue and transforming it into a hybrid artist's book. They mixed art and politics in a McLuhanesque jumble to an extent the show did not, including the Great Wall of China, a plane crash, our men on the moon, Che Guevara, Marcel Duchamp, flowers in guns, the Black Panthers, rock and roll groups, Native American earth drawings, and computer data. McShine set the stage with his text, which noted the "spirited if not rebellious" contributions, and attributed them in part to

> the general social, political and economic crises that are almost universal phenomena of 1970. If you are an artist in Brazil, you know of at least one friend who is being tortured; if you are one in Argentina, you probably have a neighbor who has been in jail for having long hair, or for not being "dressed" properly; and if you are living in the United States, you may fear you will be shot at, either in the universities, in your bed, or more formally in Indochina.[22]

This intense outburst of anger and energy against the war soon faded out. Irving Petlin attributed its demise to a fundamental characteristic of artists: "They don't know how to live the political life as part of one's regular life. It seems to be the extra feature at the cinema, rather than the way one lives one's life."[23] Petlin's own central position in antiwar organizing—from Artists and Writers Protest to Artists Call Against U.S. Intervention in Central America in 1984—was never overtly reflected in his art, which he says has "always been about the human condition in one form or another. But never in a specific sense."

Petlin did produce a series entitled "Christ in Asia" in 1967. Originally called "The Removal of the Body of Christ from Asia," it was sixty-six small oils on vellum commenting on Cardinal Spellman's 1966 Christmas trip to Vietnam, where the Cardinal "remarked from an armed helicopter that this was a war fought in defense of Christian civilization." Images of Christ and Buddha refer to the "traumatization of the East by the West: esthetically, morally, carnally."[24] As in *The Fire Children*, 1972 (fig. 17), a later comment on the war from the series "Rubbings from the Calcium Garden," jewellike color prevails but is countered by spatial bleakness. The landscape, or "history ground," is a symbol, ironically yellow with a wintry sun. The forms resting in it could be skeletal children, stone Buddhas, or salt pillars.

Although few artists sustained an art about the war, many of the art world's best-known figures opposed it by signing petitions and donating works to benefits. Alexander Calder designed a button for New Mobilization and signed it with a flourish. Sometimes, often uneasily, the war was incorporated into one token work, perhaps a kind of exorcism. The most famous of these were Jim Rosenquist's *F-111* and Claes Oldenburg's *Lipstick Monument*.

F-111 (fig. 18) was first shown in April

1965. Its speeding, intercut images include the fragmented focal point—the F-111 fighter-bomber—a helmeted diver, bubbling water, a huge tire about to roll over a fragile light bulb/eggshell, a little girl under a hair dryer, and a visceral field of canned spaghetti. Anticipating most artists' antiwar involvement, the 10' × 86' painting (later reproduced in a 3' × 25' print) was not originally viewed in that context. Rosenquist said that *F-111*'s huge size was "a visual antidote to the power and pressure of the other side of our society" and the artist's subjugation to materialism and militarism. When it was first shown, general criticism seemed to view *F-111* as a comment on the atom bomb. In an interview, Rosenquist compared the diver's gulp of breath to the "gulp!" of the atomic explosion, "an unnatural force, man-made," and connected it to a story about a bombing in Vietnam.[25]

By the time *F-111* was shown for a second time, at the Metropolitan Museum in 1968, the climate was different, and the Vietnam reference was taken for granted, although still virtually unmentioned in reviews. By the '70s it was accepted as an antiwar painting.

Oldenburg's *Lipstick Monument* (figs. 19, 20)—a 24' high, red and gold open lipstick mounted on a red tractor-tank—was installed on the Yale University campus in the spring of 1969 under the aegis of "The Colossal Keepsake Corporation," a group of dissident students and faculty; it was rolled onto the Hewitt Quadrangle without warning, and wisely accepted as a gift by the university. The idea for installing it on campus was apparently suggested by a remark made by Herbert Marcuse in a student interview that "society as we know it would end if any monument of Oldenburg's were ever truly rendered."[26] Among Yale's phallocentric gray towers, the monument looked right at home, like an unruly alumnus (though it also commemorated the university's new co-ed status). On September 21, the

lipstick and its creator were on the cover of the *New York Times Sunday Magazine*. The accompanying article by Grace Glueck called Oldenburg "one of the country's most deadpan revolutionaries" and quoted him asking rhetorically, "Why should a monument commemorate something that happened 100 years ago? It should reflect what's going on today."

The *Lipstick* was an oblique reflection of Oldenburg's experience the previous year when he was kicked by police while neutrally observing the infamous Chicago Democratic Convention brawl. Although Oldenburg continues to be one of the few socially committed "famous artists," and in 1984 made the national poster for Artists Call Against U.S. Intervention in Central America, he probably spoke for most professional artists when he admitted:

> An artist is a very artificial person . . . a little out of touch with other people's notions of life. To me, life seems as artificial as art, a product of my imagination, a monumental vision. I'm entirely too emotional, too much misled by my own infatuations, to become politically involved.

Robert Rauschenberg's 1970 work was decidedly socially oriented, and he, like others, was very supportive of the Movement. His "Currents" series of silkscreen montages included a well-distributed Earth Day poster (fig. 21). Another well-known print from the series is a mournful conglomerate, mostly mortuary history of the '60s with portraits of Rauschenberg's Texas compatriot Janis Joplin, JFK, Robert Kennedy, Martin Luther King, Jr., a man on the moon, beaten Blacks, and wounded and aggressive Vietnam soldiers. In a handwritten note on the brochure for a 1970 show at Automation House and Castelli Graphics, Rauschenberg wrote, "Signs: conceived to remind us of love, terror, violence, of the last 10 years. Danger lies in forgetting."

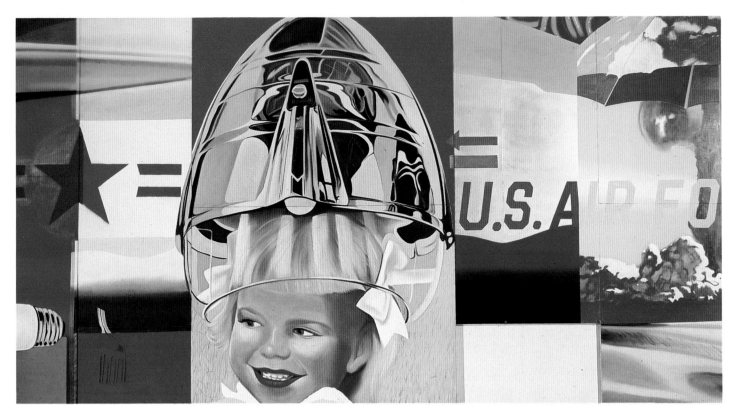

Fig. 18. James Rosenquist, detail, *F-111*, 1965, oil on canvas with aluminum, 10 × 86', private collection, Chicago.

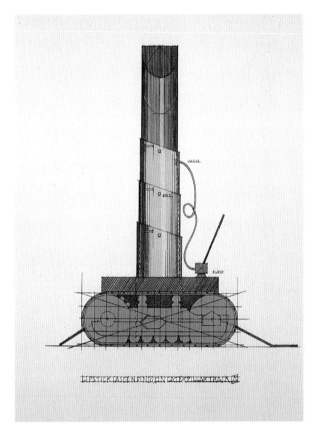

Fig. 19. Claes Oldenburg, *Lipstick (Ascending) on Caterpillar Tracks*, 1972, lithograph (cat. no. 64).

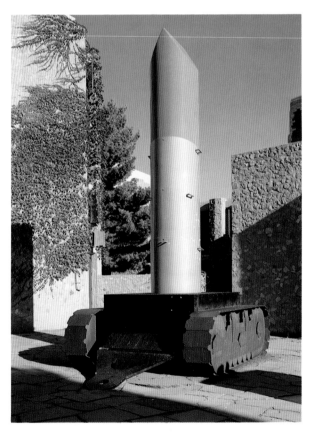

Fig. 20. Claes Oldenburg, *Lipstick (Ascending) on Caterpillar Tracks*, 1969, corten steel, plastic and wood, painted with enamel, 288 × 252 × 204", collection of Yale University Art Gallery, New Haven, Connecticut, gift of the Colossal Keepsake Corporation.

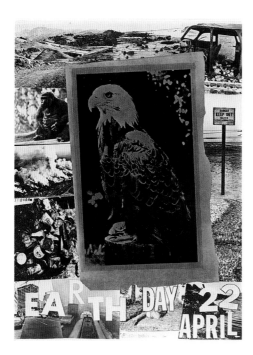

Fig. 21. Robert Rauschenberg, *Earth Day*, 1970, silkscreen, 34 × 25 1/2", collection of the Artists' Poster Committee, New York.

In an era flooded with mass-distributed images, no object could encompass the multifaceted ambivalence felt about this war. Television and film were economically out of most artists' reach, and there were no artists' books about the war aside from GAAG's later collection of its outraged letters-as-art to public figures. Installations, a relatively new form, sprawling and concrete, provided a wider screen and provided some of the better known art images. Duane Hanson's 1969 *Vietnam Scene* (fig. 22), an eerily realistic life-size tableau of four dead young shirtless mud-covered soldiers sprawled on the floor of a clean white gallery, made the TV news tangible and offered a shock akin to the experience of witnessing an accident on the street or the sudden death of a stranger.

Ed Kienholz's two major antiwar installations (both made in 1968) also evoked the media. On the left side of *The Portable War Memorial* (fig. 23), a TV provides a background for the Iwo Jima flag-raising group; on the screen is the classic Uncle Sam "I Want You" poster. One of the marines in the sculpture braces himself on an overturned metal cafe chair—one of several, with tables, that connect the war and peace sides of the installation. On the right side, a young couple snack obliviously at a hot dog and chili stand, which emerges from a blackboard bearing the names of some 475 "extinct countries." A cross formed of tombstone and eagle commemorates

"V__ Day, 19__"; you fill in the gaps.

In a 1983 interview with Carrie Rickey, Ed Kienholz said, "It hurts me; it really physically hurts me, to listen to the news."[27] His second Vietnam piece, *The Eleventh Hour Final* (fig. 24), an early manifestation of that pain, took on the media's relatively rosy view of the war and exposed the darkness behind the screen. In an average American wood-paneled living room, complete with couch, coffee table, and daily updated *TV Guide*, a television set into a tombstone is etched with daily body-count numbers over the head of an Asian child, whose baleful glass eye stares out of the box, accusing the viewer. A remote control cable to the couch also suggests where the responsibility lies.

A further extension of the narrative medium was the notion of acting out one's ideas in the flesh. Body art and Performance art were born in the late '60s of the Conceptualists' attacks on the commodifiable art object, which made artmaking seem an inadequate, indirect means of expression when compared to guerrilla theatre and political actions. The more immediate forms also evoked the fact that many other young men were putting their bodies on the line in a war. Some of the more tortuous activities of artists such as Vito Acconci, Dennis Oppenheim, and Chris Burden might have included an element of guilt, and that guilt may also have been a factor in the protest art that so often seemed "disarmed" too.

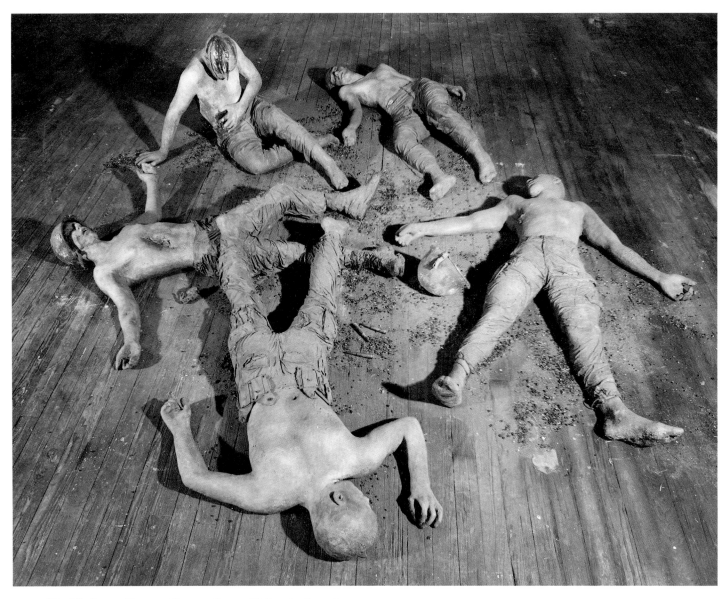

Fig. 22. Duane Hanson, *Vietnam Scene*, 1969, mixed-media
installation, Wilhelm Lehmbruck Museum, Duisberg, West Germany.

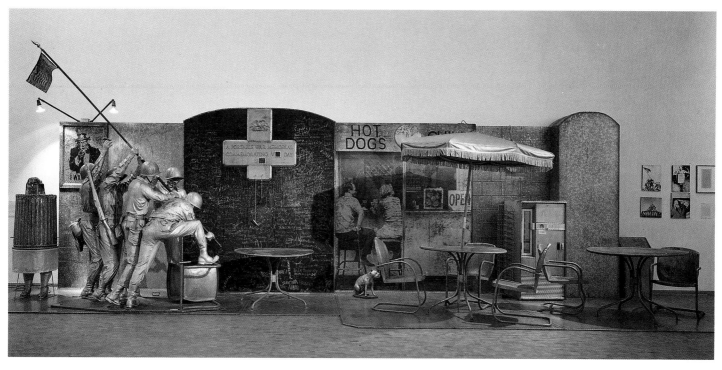

Fig. 23. Edward Keinholz, *The Portable War Memorial*, 1968, mixed-media installation, collection of the Museum Ludwig, Cologne.

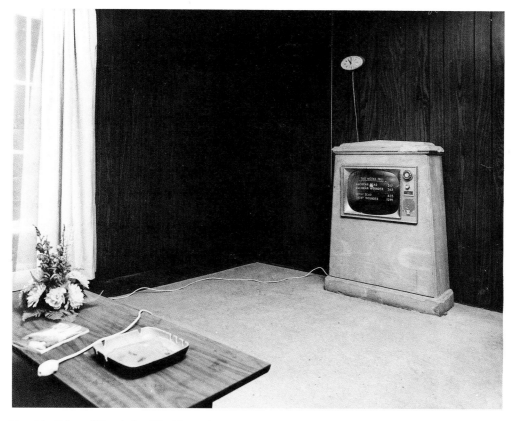

Fig. 24. Edward Kienholz, *The Eleventh Hour Final*, 1968, mixed-media installation, private collection, Cologne.

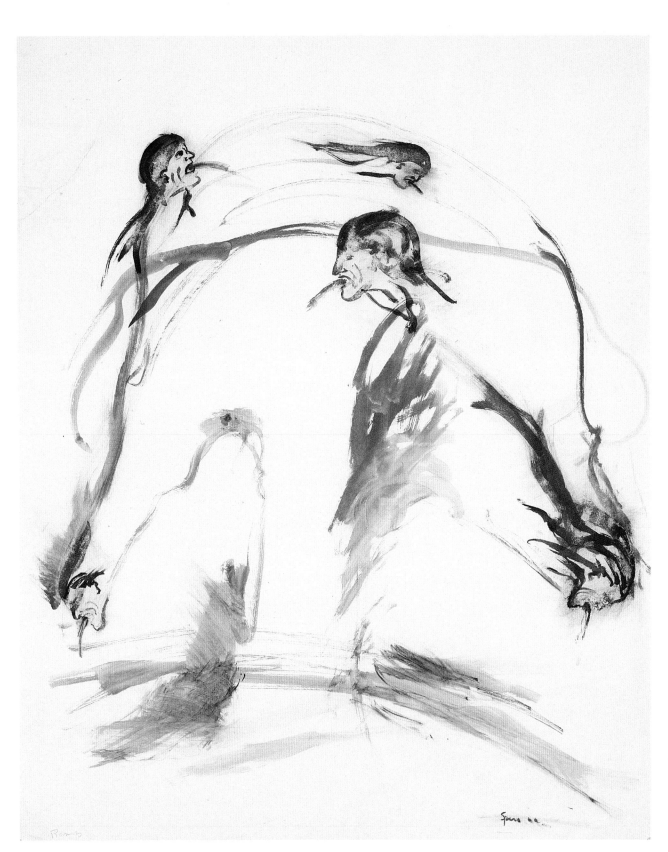

Fig. 25. Nancy Spero, *Bomb*, from the "Bombs and
Helicopters Series," 1966 (cat. no. 85).

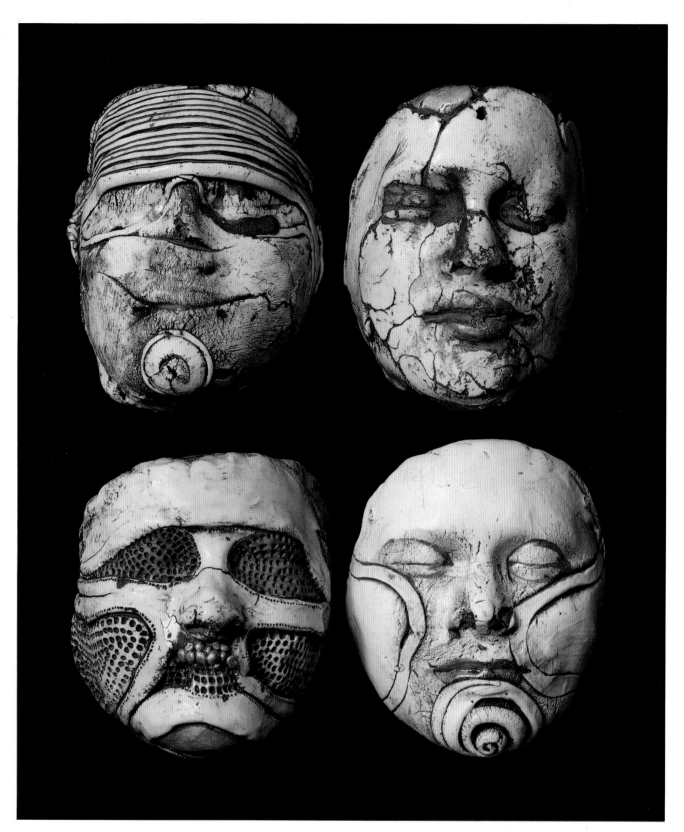

Fig. 26. Michele Oka Doner, *Death Masks*, 1967
(cat. nos. 22–25).

The war brought gender-related anxieties to both sexes. In retrospect it had special significance for women artists, since it was within the antiwar movement that women realized we too were among the oppressed. This revelation of powerlessness led to the gender polarization of the art Left when, in 1969, Women Artists in Revolution (WAR) and, in 1970, the Ad Hoc Women Artists Committee were formed from the ribs of the AWC. Analyses of power and its abuse were applied globally and domestically, contributing the still meaningful concept that "the personal is political" and vice versa.

One of the first artists to see the connections between war and social brutality against women was Nancy Spero, a member of both WAR and Ad Hoc Women Artists. She began her "Bombs and Helicopters Series" (fig. 25) in 1966, before the Women's Movement hit the art world. The work originated in images of the atom bomb and soon incorporated the Vietnam War. Nowhere has the obscenity of war been expressed with such unbridled vehemence and lyricism. The almost pretty washes on rice paper erupt into some of the angriest art ever made. Male (and sometimes female) scatological and sexual imagery prevail. Engorged phallic bombs and insect-like helicopters spew and defecate death and mutilation on tiny, bloodied, innocent, and often female victims of "search and destroy" missions. Spero later found out that the bomber pilots had used similar expressions, such as "I laid my stuff all over it."

Spero's rage against the plight of the Vietnamese civilian extended to the powerlessness of the protester, the artist, the woman, herself. She recalls being

> frustrated that I had no voice . . . that's why all these tongues. In French, "tongue" is langue, tongue and language—I was sticking my tongue out and trying to find a voice after feeling silenced for so many years.[28]

She was also sticking her neck out. It took almost twenty years for the importance of the "Bombs and Helicopters Series" to be recognized. Spero herself only fully realized what this "very private radicalization" meant when feminists began to analyze the connections between sex and the military, the male power of the bomb:

> I couldn't think of another way of showing the obscenity of the bomb, except through this expression of sexual obscenity. . . . And as horrified as people were at this work, reality was always much worse.[29]

Other women artists had similar experiences in which a submerged and subversive imagery was released by the war. In Ann Arbor, in 1967, Michele Oka Doner was making ceramic "dolls" and "death masks" (fig. 26) with ambiguously symbolic tattoos or mutilations, which student activists understood to be references to napalm victims; one appeared on the cover of a campus literary magazine. At the time Doner had no such specific intentions, but this interpretation reflected her sympathies, and she was glad to see her art so used. In 1981 Doner made a unique war memorial in Franklin, Michigan—a large silvery *Fallen Leaf,* lying on the earth.

In California, in 1969, Martha Rosler, who was later to become one of the most intelligent advocates of feminist-socialist-postmodernist "critical art," was making a series of witty photo-montages called "Bringing the War Home: House Beautiful." Shot from small collages of magazine and news photos, many pictured opulent homes invaded by the war in Vietnam: a portrait of Pat Nixon in her elegant neo-colonial parlor with a photo of a bullet-riddled Faye Dunaway from *Bonnie and Clyde* in a gold frame over the mantelpiece; soldiers visible through the door of a chic kitchen; a tank rolling through a destroyed Asian landscape visible past white iron lawn chairs. Rosler's feminist perspective (as well as a relationship to her mature work) is particularly apparent in the most striking of the series (fig. 27): a lusciously flesh-colored face with eye makeup being applied (a cosmetics ad) fills the entire frame, becoming a landscape of "miss-representation." The model's eye, however, is covered (blindered) by a black-and-white image of a Black GI pushing ahead of him at gunpoint a young Vietnamese woman (apparently a Viet Cong suspect). By Surrealistically "mating" these two different media realities—neither one to be trusted—Rosler opens up a volley of visual "shots" about outlook and inner eyes, cover-up and make-up, race and gender, power and powerlessness, ignorance and bliss.

In New York, in the early '70s, longtime activist May Stevens was working on a large painting series featuring a bald, bullet-headed, white man who appeared at different times in the guise of a bigot, a cop, a Ku Klux Klansman, and a soldier. Named "Big Daddy," this figure also appeared as a paper doll, a mask, or a facade for American society—as in the 1968 version *Big Daddy Paper Doll* (fig. 28). The series, which evolved from a sympathetic portrait of her working-class father, was transformed by Stevens's perceptions about the Vietnam War—the fact that many of those who supported the war "were my people, my relatives; I understood them; I loved them and hated them."[30] During this period Stevens demonstrated against the war and watched her son burn his draft card. Only when other women artists assumed that her motives were feminist as well as antiwar, that the figure stood for the patriarchy as well as the establishment, did Stevens herself begin to understand that dimension. At the same time she realized that she was one of those women who had been playing a subservient role in the antiwar movement, and in response, like so many others, she rebelled. Finding a sisterhood who felt the same way, she became a leader of the burgeoning women's art movement, one of the few to combine feminism and socialism in her painting.

For the most part, the war came as a ghastly surprise to North American artists. At first it encroached on their art more than their art aspired to intervene in the war. Leon Golub, however, had been focusing his art on the universal notion of males in combat since the early '60s. When the American public began to see that Vietnam was "our war," a vortex was provided between Golub's monstrous, nude, heroic figures and a daily reality. His first overtly activist work —in which

Fig. 27. Martha Rosler, *Untitled*, from "Bringing the War
Home: House Beautiful," 1969–71 (cat. no. 72).

Fig. 28. May Stevens, *Big Daddy Paper Doll*, 1968
(cat. no. 91).

Fig. 29. Leon Golub, *Vietnam II*, 1973, acrylic on canvas, 120 × 480", courtesy of the Barbara Gladstone Gallery, New York.

the protagonists are historically recognizable—was the "Napalm" series, begun in 1969. In 1972, when he began his huge "Assassins" (later changed to "Vietnam" for timeliness), including *Vietnam II* (fig. 29), he had modernized his antique warriors by clothing them and arming them with modern weapons, while their bodies, gestures, stances—the most expressive elements— changed more slowly toward naturalism.

The ripped canvas in Golub's Vietnam works can be seen as a kind of self-censorship (some things are too painful to be pictured or seen), or as a veil torn away from the grisly reality, or as physical parallels to that pain, like the unbearably dry, scraped surfaces. (*Vietnam I* is actually shaped like a gun or a penis.) Golub's color, limited to a turgid mix of red, brown, black, and gray, with the quasi-khaki of raw canvas, provides another tangible metaphor. The guns are nasty, pointy things and the soldiers fight shirtless, as though at sport—or because the fires of hell are so hot.

Like Spero, Golub wallows unabashedly in power and aggression, but not as an onlooker. His paintings have the tangible presence of war directly, even casually, experienced. This is a man's picture of a war as possible, rather than a woman's picture of a war as unspeakable, fan-

tastic. Donald Kuspit has called Golub's activist paintings

> perhaps the most profound demonstration of masculine and military psychology in art today. . . . Expressionism also creates the impression of being enclosed within a world rather than witnessing it from without, from a perspective that doesn't belong to it.[31]

Golub's paintings verge on the sense of real violence that surfaces in the veterans' work, although few survivors would picture themselves shooting directly into a crowd of terrified, unarmed, naked civilians, as Golub did in *Vietnam II*, which centers on a boy's screaming and bewildered head, staring out at the viewer, like the famous photograph of Kim Phuc running naked and burning down a road.

In *Vietnam I*, however, the three soldiers are themselves both threatening and almost vulnerable, semi-clothed, alone in space, while the victims are temporarily shielded by a smoke-like cloud. Space is always significant in Golub's work: "I deal with how we intervene into and deal with space."[32] He worked from the ubiquitous news photos of the war, but despite the basic immediacy of his sources, the paintings are marked by a curious timelessness, or slow motion. He

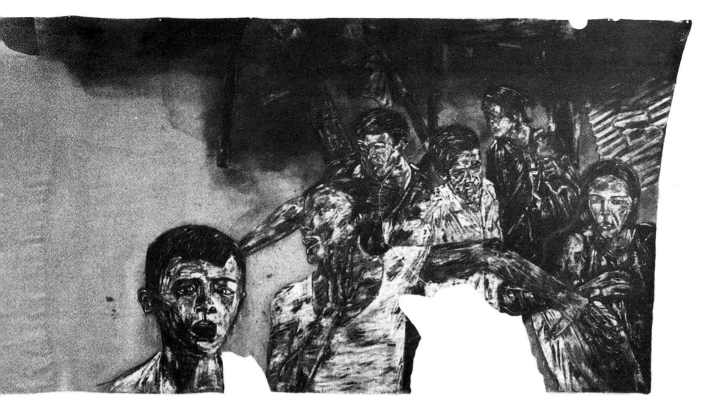

pictures the moment before the action, when violence is being drifted into—just as the U.S. slowly drifted into a full-scale, undeclared war. Time span is spatially suggested by the void that separates attackers and victims, a space dramatic in its blankness. On one level, Golub sees himself as "simply a reporter." On the other hand, he insists on the traditional role of art as beyond reality:

> There was World War II, Korea, Vietnam. How are you going to make contact with those fantastic numbers of slaughters? You can't do it by making pretty pictures about it. You have to create these kinds of stylized forms which are so brutal that they jump beyond the stylization.[33]

This was the strategy chosen for some of the most deeply felt art about the Vietnam war that was executed at home. Golub, Peter Saul, Red Grooms, and Peter Dean sometimes exhibited together in New York in the late '60s as embattled expressionists on Minimalist turf. Grooms's work was and is so exuberantly beneficent that, for all its accessibility, he never made an effective indictment of the war. Peter Dean, on the other hand, with his fantastic and infuriated approach to politics, was more successful. In 1967 he had a

"Cannibals" show at the storefront Elizabeth Street Gallery which was as obdurately off the beaten track as the art itself. The grotesque images of predatory power mongers balance on the edge of cartoon villainy. Included were General Westmoreland and a Lyndon Johnson foaming bloodily at the mouth (fig. 30), which echoed the protest chant "Hey, Hey, LBJ, How Many Kids Didja Kill Today?" Dean continued his polemics with the Rhino Horn group in 1969. His paintings have remained raw, political, and unexpected—a kind of magic social realism.

Peter Saul went, and still goes, for the verge of racist and sexist pornography in his Vietnam paintings, the best known of which is *Saigon*, 1967. A yellow whore labeled "innocent virgin" is the central figure of this writhing composition, also populated by "her sister" and "her father"— two more grotesque illustrations of the ugliness of suffering. A coke-guzzling GI and a frenzy of eyeballs, helmets, bullets, mines, snake-like limbs, and bilious comic-book colors add up to a vision of sheer unmitigated violence and vulgarity, labeled at the left in pseudo-Oriental writing "Torturing and Raping the People of Saigon." *Fantastic Justice*, 1968 (fig. 31), is a simpler but equally brutal image in which a red LBJ is crucified on a yellow palm tree-cross, a firecracker with

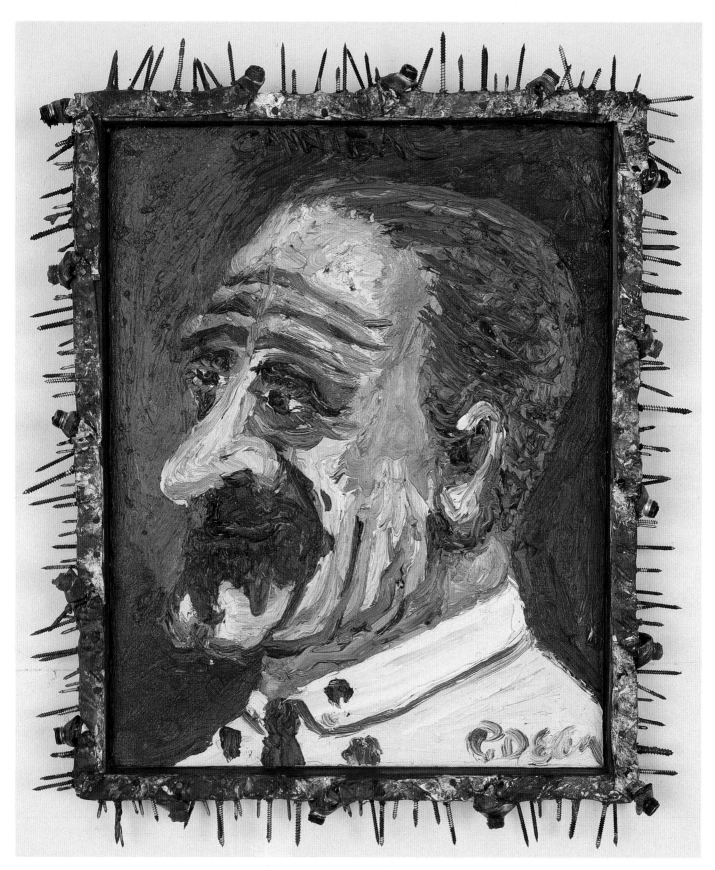

Fig. 30. Peter Dean, *No. 1 Cannibal*, 1967 (cat. no. 21).

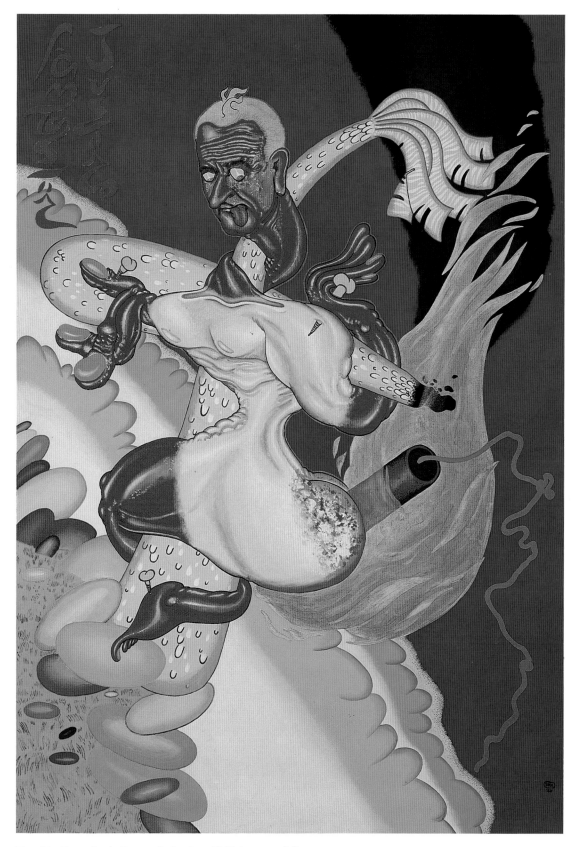

Fig. 31. Peter Saul, *Fantastic Justice*, 1968 (cat. no. 81).

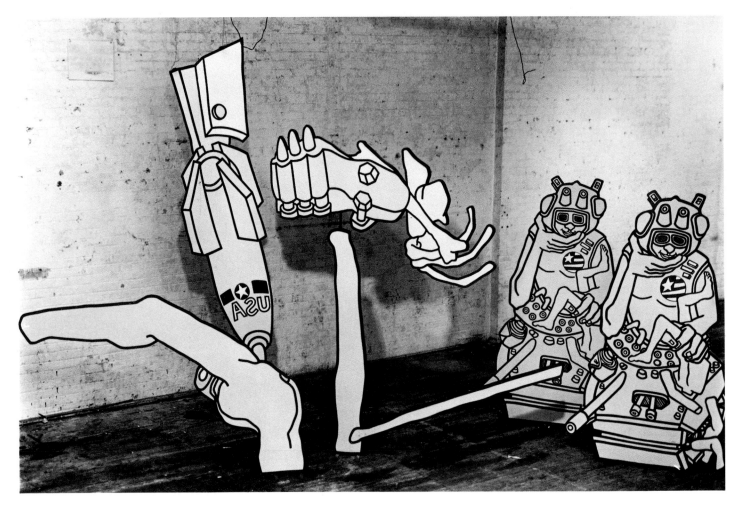

Fig. 32. Bernard Aptekar, *Our Men and Their Works*, 1968–70 (cat. no. 2).

a long fuse up his ass.

Bernard Aptekar's changeable, modular sculpture, including *Our Men and Their Works*, 1968–70 (fig. 32), also pits the broad humor of popular culture against the earnest realities of state terrorism. His flat, black-outlined wooden figures, painted on both sides, are caricatures—weirdos with guns and phalluses drawn for the next rape—who seem to have escaped into three dimensions by exploding an underground comic. Angry and overstated, sharing Saul's orgy of vulgarity, they mix sci-fi and hi-fi. A biker-soldier-cop dressed in stars and stripes, wretched victims, staunch defenders, alien cannibals poised over severed limbs, bristling with bombs and planes, these conglomerations can be shrunk or expanded—out of scale and out of sync even with their own body parts. Their titles are like pop fiction too: *Defeat of the City of Plutonium, Any Secretary of State*, or *They Turn Everything Into Garbage*.

Oyvind Fahlstrom, who died in his forties in 1976, used comic figures, modular elements, and changeable fields in a far more intellectual manner. With his mixed Brazilian, North American, and European background, he brought to his art an internationalist's knowledge and concern. He was also more interested in comic strips—the serial narrative aspect—than in comic styles. In the late '60s, Fahlstrom began to make free-standing tableaux and the "variable" or "game" paintings, including *CIA Monopoly*, 1971 (fig. 33), that lent themselves so well to the constant, unbalanced changes in the Vietnam era. Fahlstrom's variables are world models, intricate puzzles with movable magnetic parts that seduce the viewer into a miniature political psychodrama. The pretty colors change according to the extent of superpower involvement. These pictures are also astute political and economic analyses in visual form, with maps, diagrams, and charts used to inform and, at the same time, to parody the seriousness with which such data are accepted. Strangely delicate figures point guns or crutches or fingers at each other almost randomly. Criticized for trying to sell "radical art" to rich people,

Fahlstrom replied that by the same token Costa Gavras should not have made *State of Siege* as a commercial feature film reaching a very large public. Fahlstrom hoped to sell enough expensive originals to pay for the manufacture of mass multiples; the first step was the folded insertion of his big *World Map* drawing in the May 1973 issue of *The Liberated Guardian*, so that it was available for twenty-five cents.

Another product of an internationalist position is Rudolf Baranik's *Napalm Elegy I* (fig. 34) of 1966–74, the first large work in a series begun in 1966, inspired by a newsphoto of a Vietnamese boy badly burned by napalm. Baranik, who was born in Lithuania, served with the U.S. Army in World War II and has traveled extensively ever since. He is at heart an abstract painter who calls himself a "socialist formalist."

These black, gray, and white paintings are indeed elegies, unique among art about Vietnam for their conversion of anger into a monumental poetic melancholy. At first the almost unrecognizable head—both corpse and fetus—seemed to strike a metaphysical chord between photography and painting. Later the image was to assume still more significance in Baranik's entire oeuvre, located as a poignant median between the loss of his parents in the Holocaust and the death of his son in the '80s. Baranik's sympathy with innocent Vietnamese victims in the '60s permitted his grief from World War II to surface. The "Napalm Elegies" are beautiful rather than abrasive, almost as universal as paintings inspired by a specific political situation can be and still have meaning as contemporary protests. The white glow pervading many of Baranik's works is a memory of the long "white nights" in the Lithuania of his childhood; it also recalls the white light reported by people on the verge of death. Despite the timeliness of the "Napalm Elegies" source, there is a timelessness, a stillness, a silence about the paintings that goes beyond Vietnam, even beyond war.

Others have noted that, when the boy's burned head is gently laid to rest horizontally, it resembles Brancusi's *Sleeping Muse*. The original photo showed the boy sitting up. ("The power of an inverted force is not seen easily," Baranik has remarked.)[34] Sometimes the skull looks transparent; sometimes it is repeated or fragmented into total abstraction; sometimes it appears as though in a nocturnal landscape, like a subterranean moon.

Over the years, Baranik has consistently taken a different position from many of his colleagues on art and protest: "I have much more in common with the Minimal artist who states something very reductive and elusive, the silent left, rather than with the expressionist who shouts louder than I do," he said in 1977, insisting that an artist can be both an elitist and a revolutionary. "In other words, those who whisper what I want to say are my allies, those who scream vulgarize it."[35] Yet Baranik is the peace activist *par excellence*, an initiator of many of the early antiwar actions who has remained an activist to this day. He has designed posters carried by thousands in marches. Of these works he says: "They are strong propaganda, good art, but not my work proper. . . . They are different wings, moving at different tempos, in the offensive for life."[36]

Fig. 33. Oyvind Fahlstrom, *CIA Monopoly*, 1971 (cat. no. 27).

Fig. 34. Rudolf Baranik, *Napalm Elegy I*, 1966–74 (cat. no. 4).

Antonio Frasconi, the Uruguayan printmaker whose recent woodcuts on the Latin American *desaparecidos* are bold enough to contain their tragic dimensions, also made some major prints about the war. His 1967 book-object, *Viet Nam!*, combines the graphic impulse with a sculptural presence, its oversize pages heavy with graphite and with historical urgency (fig. 35).

Sam Wiener was one of the few artists to concentrate on the American dead. In 1970 he made one of the Movement's most simple and haunting works (fig. 36). Originally titled *45,391 . . . and counting* (it changed with the latest body counts from Vietnam) and now titled *Those Who Fail to Remember the Past Are Condemned to Repeat It* (apropos of Central America), it is a small, open-topped box sculpture lined with mirrors in which a row of flag-draped coffins expands infinitely into endless other rows of coffins, escalating into infinity, like the war. Viewers feel as though they are in a Surrealist dream hall of horrors—silent and awesome and absolutely terrifying in its cool, methodical illustration of death. Wiener also made a mass-distributed poster from the image; it too was resurrected and distributed again when Central America heated up in the early '80s.

Robert Morris, although he was active in Art Strike and was at one point ironically called "The Prince of Peace,"[37] made no work that was specifically about Vietnam. But in 1970 he produced a series of lithographs called "Five War Memorials"

—images of fantasized earthworks (fig. 38). They showed bleak, geometric containers for atomic waste, or postwar craters under ominous skies. Their focus was nuclear war—not inappropriate, as we learned later that the U.S. had considered using nuclear weapons in Vietnam.

The role of antiwar artists of color in the U.S. was complicated and intensified by race and class. If soldiers of color bore an exaggerated burden of the fighting and drudgery "in country," the role of artists of color in the U.S. was also complicated by oppression. Well aware that for so many of their people Vietnam was an alternative—albeit an unattractive one—to a futureless America, and involved in liberation movements at home, African-American artists in particular spoke out against the war.

Cliff Joseph was one of the founders, with Benny Andrews, of the Black Emergency Cultural Coalition in New York, which often collaborated with the Art Workers Coalition. Joseph's 1968 painting *My Country, Right or Wrong* (fig. 37) sets isolated, flag-blindfolded people, both Black and white, wandering in a field of bones and bombs. In the background, a cross, a Star of David, and an upside-down flag indict all kinds of militaristic chauvinisms. Painted meticulously, it seems both real and dreamlike.

Robert Colescott summed up resentment against the war in the Black community with his usual acid humor in the 1971 *Bye Bye Miss*

Fig. 35. Antonio Frasconi, *Untitled*, from "Viet Nam!," 1967, woodcut, 29 × 23", courtesy of the Terry Dintenfass Gallery, New York.

American Pie (fig. 39). An almost caricatured African-American GI prowls the bottom part of the painting, a burst of fire from his gun parting a cloud in the shape of North and South Vietnam. Above him looms the rosy nude blond goddess, "Miss American Pie," with "Bye Bye" and the pie in the sky over her head, the small slice out of the pie echoed artfully in her pubic region. Rock music, "Myth" America, the worship of false and unfamiliar gods (or the worship of sex), and the protection of one's "mistresses" are all cheerfully wrapped up in this strong antiwar, anti-racist (and perhaps sexist) work.

Kay Brown's 1969 *The Black Soldier* (fig. 40) is a collage showing a circle of heads, including that of a blank, masked Death, the ubiquitous pointing Uncle Sam (captioned "Up Your Life"), young soldiers, alive and dead, and in the center, a clay- or mud-surfaced mask that seems to combine African and Asian features. Jagged edges force this vision out at the viewer. In another work in this series, called *The Devil and His Game*, Brown showed Richard Nixon pulling a crescent of African-American children from the arms of a robed Martin Luther King.

In August 1964, the news that the bodies of murdered civil rights workers James Chaney, Andrew Goodman, and Mickey Schwerner had been found coincided with Lyndon Johnson's announcement of the escalation of the war in Vietnam after the Tonkin Gulf "incident." This convergence was not lost on many in the Black community. As early as 1965, flyers were circulated within the Black Freedom Movement that read:

Negroes should not be in any war fighting for America. . . . No one has a right to ask us to risk our lives and kill other Colored People in Santo Domingo and Vietnam, so that the white American can get richer.[38]

In 1966, the Student Non-Violent Coordinating Committee (SNCC) formally linked the war in Vietnam and the Black struggle for rights, raising painful questions about American hypocrisy in promoting "free elections" in Vietnam, but not in the South. The leaders encouraged young Black men to refuse military service and "to use their energy in building democratic forms in this country."[39]

Soon afterwards, Martin Luther King, Jr., himself began to take a more militant stance against the war. In April 1967, he gave his historic address at the Riverside Church in New York, definitively linking the war and the civil rights movement. Titled "A Time to Break Silence," it blamed "adventures like Vietnam" for drawing "men and skills and money like some demonic destructive suction tube" from the hopes and new beginnings of the anti-poverty programs and civil rights movement. With prescience, Dr. King even tied the war into U.S. policy in Latin America, citing U.S. military "advisors" in Venezuela, "the counterrevolutionary action of American forces in Guatemala," "American helicopters being used against guerrillas in Colombia," and "American napalm and Green Beret forces active against rebels in Peru."[40]

On the west coast, Latino activists carried

Fig. 36. Sam Wiener, *Those Who Fail to Remember the Past Are Condemned to Repeat It*, 1970 (cat. no. 104).

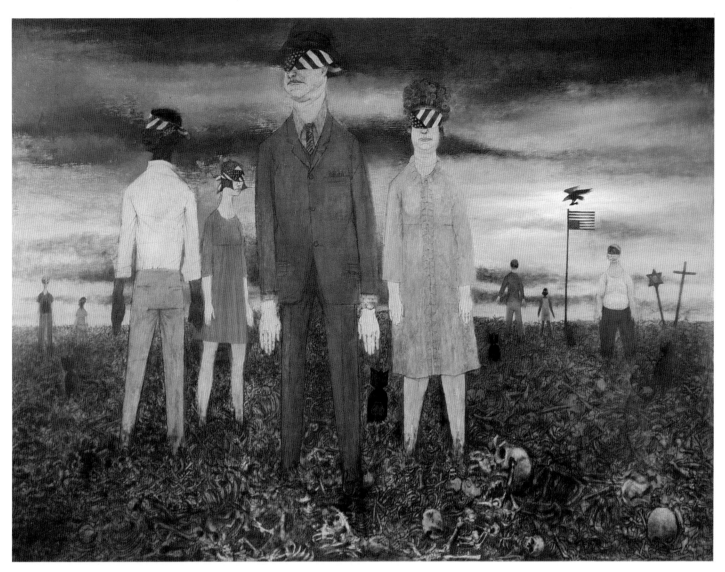

Fig. 37. Cliff Joseph, *My Country, Right or Wrong*, 1968
(cat. no. 54).

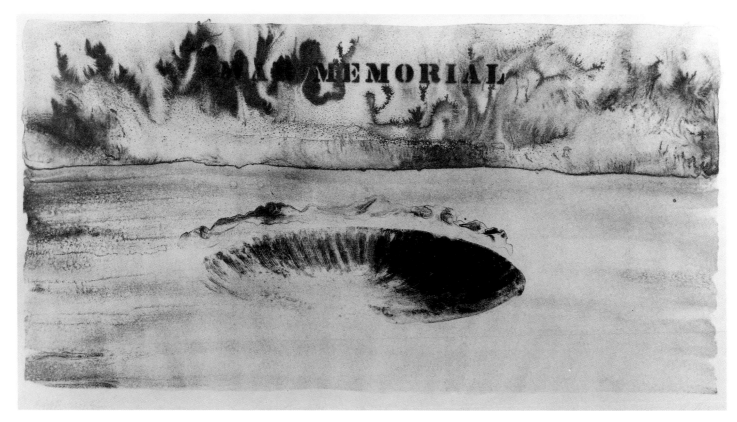

Fig. 38. Robert Morris, *Crater with Smoke*, from "Five War Memorials," 1970 (cat. no. 61).

picket signs reading "No Vietnamese ever called me a dirty Mexican." Chicano artists played a critical role in the rising self-awareness of the Latino community, and in the late '60s, antiwar activities increasingly became the focus of this movement. As early as 1967, Rene Yañez, a member of the Chicano artists collective Mexican American Liberation Art Front (MALAF), conducted an antiwar ceremony involving a cross and a candle. Many of the murals proliferating throughout the Chicano communities contained antiwar messages. Carlos Callejos's *The Wonderful World of Corruption* condemned CIA involvement in the influx of Southeast Asian heroin into the Barrio (also the subject of Jerry Kearns's *El Norte*, fig. 80). It depicted Mickey Mouse dancing in front of an American flag, its red stripes dripping blood, in an effort to distract attention from the dead bodies with needles in their arms. The mural shocked even the Barrio, and was destroyed almost before the paint dried.

In 1970, Chicano television newscaster Ruben Salazar was gunned down by Los Angeles police during the East L.A. Moratorium protesting the number of Latinos fighting and dying in Vietnam —an infamous incident recorded in a 1986 painting by Frank Romero. In response, the Chicano performance group Asco (Gronk, Willie Herron, Harry Gamboa, and Patssi Valdez) performed *Last Supper*, and, on Christmas Eve 1971, they performed *The Stations of the Cross*—an antiwar piece ending with the placement of a cross at a Marine recruiting center.

Silk screen graphics were, and are, a specialty of the Chicano community. Jose and Malaquias Montoya, Esteban Villa, Armando Cid, and other artists from Sacramento formed the graphic artists collective the Royal Chicano Air Force, and Rupert Garcia, one of the best-known Chicano artists to emerge from this period, was first recognized for his posters. Garcia guarded planes, bombs, and other ordnance at a secret base and in the jungles of Thailand in the late '60s. Returning to study art at San Francisco State College, he became involved in the Chicano community and the antiwar movement, producing a series of drawings related to Vietnam and an antiwar poster for the East L.A. Moratorium in 1970.

Garcia moved into painting large pastels in the mid '70s, producing one Vietnam-related work in 1976 entitled *Political Prisoner*—an image of a Vietnamese woman gagged. Disturbed by parallels between U.S. foreign policy in Central America and Southeast Asia, he produced two more works about Vietnam in 1984, *Prometheus Under Fire* and *Fenixes* (fig. 42). (Operation Phoenix was a CIA "neutralization" program in Vietnam.) Devastation and genocide are immediately readable in the images of helicopters swarming like predatory insects over dead soldiers. A man is set on fire; a figure with a gun is taken from a photograph of a Sandinista during the Nicaraguan revolution, thus giving the title another dimension—the cyclical death and resurrection from the ashes of the revolutionary impulse. Garcia transfers the drama of the photographic gesture into the doubly evocative medium of "fine art," getting the best of both worlds.[41]

In New York, Puerto Ricans were also conscious of their lack of options, and of the number

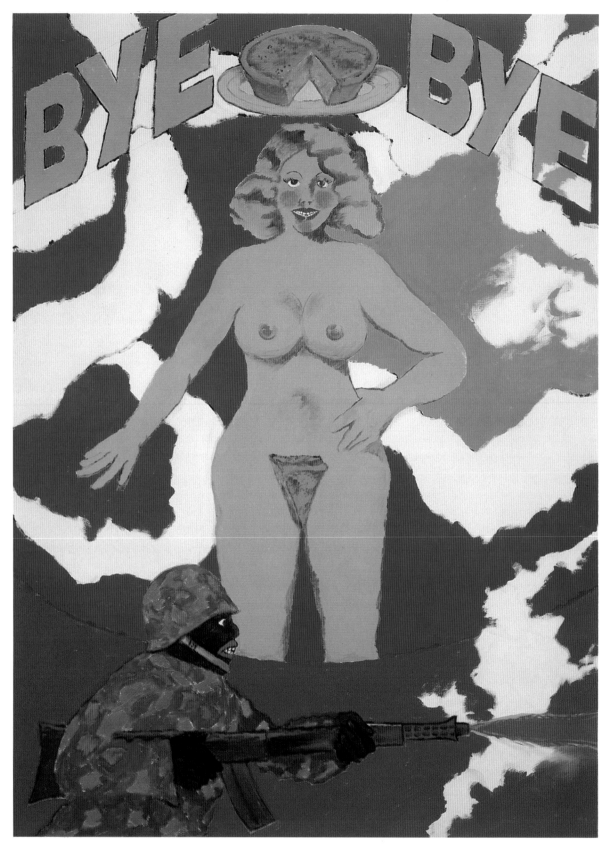

Fig. 39. Robert Colescott, *Bye Bye Miss American Pie*,
1971 (cat. no. 20).

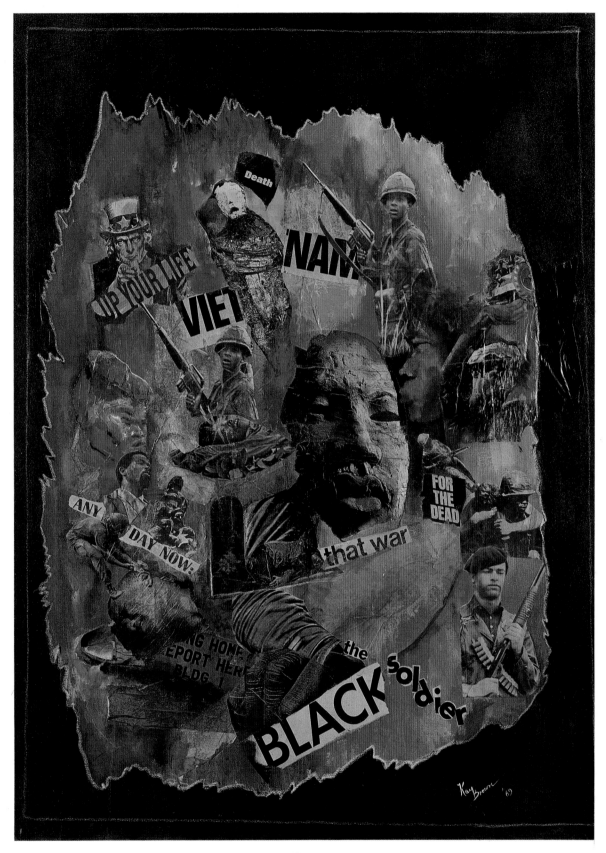

Fig. 40. Kay Brown, *The Black Soldier*, 1969 (cat. no. 8).

of soldiers drawn from their ranks, both on the mainland and on La Isla. The columns of young soldiers' photos in Carlos Irizarry's 1970 double print *My Son the Soldier* predicted the Vietnam memorial. In another double print—*Moratorium, 1969* (fig. 41)—Irizarry incorporated some of the same pictorial elements in a gridded panorama indicting all war, with images ranging from Picasso's *Guernica* to Johns's green and orange *Moratorium* flag, from a repeated yellow Nixon to an altered Iwo Jima monument in which the flag is replaced by a giant yellow flower.

For Asians, the conflict was particularly sharp, as is made clear in James Dong's 1969 *Vietnam Scoreboard* (fig. 43), a double portrait of a grinning fighter pilot and an Asian-American immigrant family. The notches on the plane, representing enemies shot down, are rendered as silhouettes from the family portrait.

If Vietnam was a different war, it produced no fundamentally different ways for art to oppose war. Skeletons, victims, victors, and swords (then guns and bombs) have been universal symbols for the fear of death, the anger and pride of combat. Hypocrisy and class exploitation have been constants even in the "good wars." Flags and wicked generals; brave soldiers and dumb soldiers; profiteering businessmen; black humor; the post-Holocaust responsibility to think before following orders; the dead, the wounded, the crippled innocents; and always gore galore: these remain the basic vocabulary of art against war.

At the same time, it has become harder and harder to make a positive representation of peace. The dove has had its wings clipped by saccharine depictions and overuse. And as writer D. J. R. Bruckner has pointed out, "pity for the individual or even for the kingdom does not amount to a statement against war,"[42] any more than the mere image of a bomb or a soldier constitutes "political art." Yet the audiences are new each time around, and so are the artists. Perhaps war as a phenomenon (not as an historical event) has to be constantly rediscovered within the contemporary creative vocabulary. Vietnam is different because, perhaps for the first time in the modern history of visual art, a large number of those creating the record also fought the war.

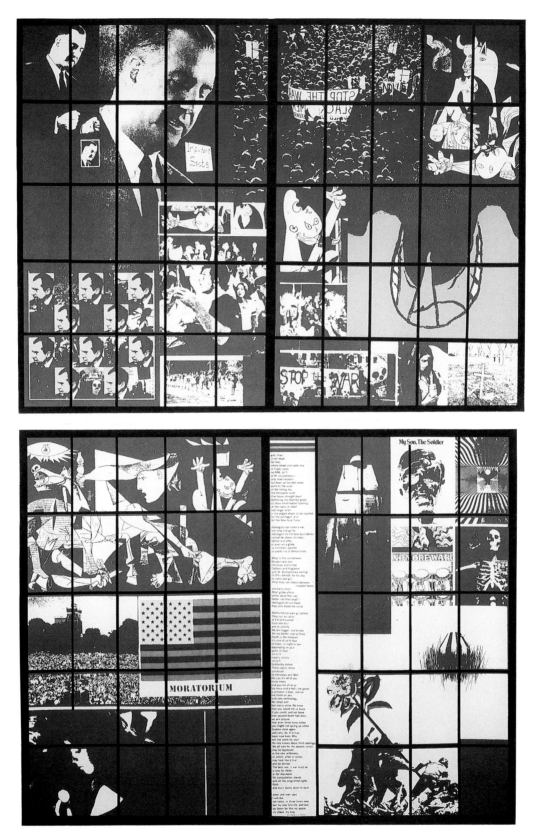

Fig. 41. Carlos Irizarry, *Moratorium*, 1969 (cat. no. 52).

Fig. 42. Rupert Garcia, *Fenixes*, 1984 (cat. no. 29).

Fig. 43. James Dong, *Vietnam Scoreboard*, 1969 (cat. no. 26).

"THERE IT IS"[1]

"IN COUNTRY"

I guess Vietnam is just a beautiful, very poor tropical country where something terrible happened once.
—Jim Kurtz, 1987.[2]

In 1980 an exhibition called "The Vietnam Experience," organized by veterans Bernard Edelman and Richard Strandberg, opened in St. Paul and began to travel around the country. It came to New York in the fall of 1981—to Central Park's Arsenal Gallery, appropriately enough. In the brochure the organizers noted that this collection of art by veterans included "no political statements, no examination of the rights and wrongs of Vietnam; just how it was." They hoped, however, that the show would help people "talk about it, to deal with it on a personal level, to clear away some of the stifling silence that surrounds" the war. No political statements were necessary. If the art was primarily illustrative rather than avant-garde, it effectively opened the wounds for anyone who had been old enough to think in the '60s. Memories pounded back to the surface, to the rhythms of the rock and roll that accompanied the show and was so much a part of the war on both fronts. In 1981, another exhibition, organized by the Vietnam Veterans Art Group (VVAG), also began a national tour, and continues today, constantly accruing works as veterans continue to peel back the layers of pain and suppression.

In 1982, with the dedication of Maya Lin's Vietnam Memorial in Washington (fig. 61), the floodgates opened. Movies multiplied, shelves of memoirs and novels appeared in drugstores and airports, and artists who had not served also began to remember Vietnam, often prodded by events in Central America. As Joan Seeman Robinson, who is writing a book on art and Vietnam, has observed:

Despite the constant disclaimers of soldiers and witnesses that war is ultimately indescribable, the necessity of articulating its impact doesn't diminish. It is an indispensable aspect of the need to image the substance and aura of perplexing and traumatic experiences in a visual, wordless, and reconstructive medium.[3]

For many veterans, the arts have provided what poet W. D. Ehrhart describes as "an outlet, a way of understanding turmoil in constructive energy." "The national experience is still unresolved," he says, "but, personally, I've closed the circle."[4] Novelist Tim O'Brien argues that vets' art is more personal than political

because the issues you confront are personal, not political. Staying alive, burning a village, watching the bombs fall . . . being scared, being brave. . . . Those are the things that go back to Homer. Those are the ancient things.[5]

Several themes dominate the veterans' work regardless of the level of their professional art training: the anguish of participating in killing, torture, and other atrocities; the fear of what would happen if you didn't give as good as you got; and the polarity offered by the beautiful landscape, often pictured as though no war existed, devoid of fire, war machinery—and people. Perhaps the theme reiterated most often is what Bernard Edelman identifies as

the camaraderie born of shared and intense experiences that binds those who were there. Particularly now, ten, twelve, twenty years

after, these ties are being reaffirmed as veterans emerge from a spiritual exile that is as much a legacy of the war as the physical scars of combat.[6]

As we know now from the vast literature by and about Vietnam vets, the war refused to get lost after 1975. It emerged in nightmares and in daily lives made nightmarish not only by memory but by official neglect and political circumstances, by Agent Orange, post-traumatic stress syndrome, and other less identifiable residues. The war became a kind of jungle rot that could be cured only by the bright light of catharsis. Of those artists who returned to study art under the GI Bill, some don't include Vietnam in their resumes or intentionally include it in their art, but they are aware when it creeps into their imagery, invisible to everyone but themselves.

Most of these artists found that Vietnam as a subject for artmaking bubbled up a decade or so after their return from combat. They found that a point arrived when dealing with it became inescapable, if not necessarily desirable. Most would have preferred to put Vietnam behind them and keep it there, but they could not, given its economic and physical consequences—and their dreams. This rejection of memory was not only protective; it stemmed not only from the mistrust and contempt with which some vets were greeted by some of those who opposed the war, not from the shame of those who hated to see America lose. It was also a consequence of the need to assimilate the war experience. As Michael Aschenbrenner recalls,

Upon returning to the U.S. from combat in Southeast Asia during the summer of 1968, the social climate was such that I went into a long period of denial and introversion. This period lasted nearly seven years. Then I began to produce objects for which I had no clear idea of their meaning. It was nearly ten years after my return that I began to define the origin of these pieces.[7]

At first, he found himself making intentionally offensive paintings about war, filled with helicopters, snarling dogs, M-16s, claustrophobic rooms, violent fields of orange, or turbulent skies. They were aggressively brutal in forcing their pain on the viewer. Aschenbrenner now works with glass, in a relatively calm, formalized approach. Glass has the strength, beauty, and fragility of human bone and becomes a material metaphor for his imagery of war and death, from Vietnam to El Salvador to visions of nuclear winter. Although people still see the pain and anger in this work, Aschenbrenner insists:

My thoughts on these pieces are filled with feelings of warmth, gentleness, and regret. In much of my work there is a certain sadness, humility, and seriousness free of satire. If the glass is broken, it has been cared for and bandaged.[8]

The bones in Aschenbrenner's paintings and sculptures are those of the human leg. He was injured in a parachute jump during the Tet Offensive in 1968 near Laos, "where we weren't supposed to be." Almost abandoned in the jungle,

Fig. 44. Michael Aschenbrenner, *Damaged Bone Series: Chronicles 1968*, 1982 (cat. no. 3).

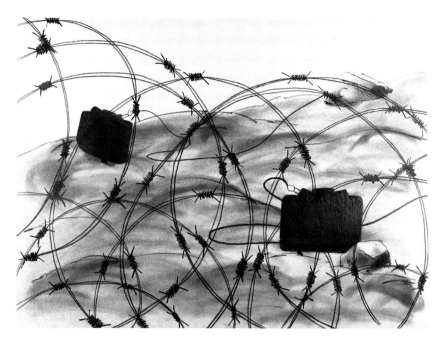

Fig. 45. John Plunkett, *Claymores and Barbed Wire*, 1986 (cat. no. 67).

rescued at the last minute, he ended up in an army hospital where he watched his own leg heal while a friend's was amputated. This friend—Harris—became an alter ego: "He brought out something in me from before the war. He kept me a feeling, human person."

Over six years, beginning in 1980, in the "Damaged Bone" series, Aschenbrenner compulsively repeated this image in a wide variety of contexts and mediums. The leg bone—cracked, bound, bandaged, splinted, and healed, the bone as a bow, as a limb on the tree of life—is sometimes attacked by tiny tanks and guns. Sometimes it dominates an assemblage or landscape, the part standing for the whole—a leg standing for all the bodies battered in all wars, and recalling prehistoric burials in which certain bones were separated for symbolic reasons to encourage rebirth. The apotheosis of this image is *Damaged Bone Series: Chronicles 1968* (fig. 44), originally 10' × 25', a wall full of fragments made into a new whole, suggesting medieval paintings of resurrection on Judgment Day. The metaphor of destruction and repair, or death and rebirth, finally constitutes a positive reading of the war experience, a reflection of the process of working through it.

There is a crucial, if elusive, difference between art made "in the world" as protest, and art made from direct experience "in country." The authenticity of the experience itself, even when translated with less polish, carries it further,

deeper into meaning than the best-intentioned and most skillfully-wrought objects by non-vets. Antiwar art in the U.S. provoked thought, inspired action, and exposed lies. Neither group can avoid death and horror. But the work by veterans is, curiously, less exaggerated. Artists trying to imagine war from a safe home base could not have made it worse than it was, but the esthetic means with which they were equipped to express their rage lacked something—roots perhaps—that we didn't miss until the body of veterans' art came to light in the '80s. As Sondra Varco, director of VVAG, has said, "It is the art of warriors. Clearly not meant for the faint of heart. . . . I see a lot of agony in the art. There is no feeling of victory. These people don't feel like heroes."[9] Nor do they feel exactly like villains, but often like victims.

John Plunkett pictures war as the incursion of the culture of war into nature, and into a culture being destroyed by war. He works with graphite on canvas or paper—misty black and white landscapes that pay homage to Asian traditional art (figs. 45, 46). They show trees bristling with rifles, skies with majestic clouds rivaled by the smoke of armaments, helicopters dwarfed by mountains, a row of explosive puffs illuminating a dark field in regular patterns, nearly abstract. A poetic irony is evoked as delicate forms result from bullets landing in water, or a Claymore mine blasting off. Plunkett says he makes art to help himself understand violence:

Fig. 46. John Plunkett, *Nui Ba Din*, 1987 (cat. no. 68).

My work is not about moral issues confronting present-day life. What it is about is the extreme ugliness of violence; the ripping of skin from bone. Violence is not always loud. It is sometimes quiet and quick. Sometimes it is a feeling in the air, ready to erupt.[10]

Much of the most impressive work in the traveling Vietnam Veterans Art Group exhibition is less mellow. For many vets, the ambivalence has not been resolved, and probably never will be. As William Broyles wrote in his book *Brothers in Arms*:

War was an initiation into the power of life and death. Women touch that power at the moment of birth; men on the edge of death. It is like lifting off a corner of the universe and peering at what's underneath. War marks the men and women who are caught up in it for life. It visits them in the hour before sleeping; it comes to them—bringing grief, pride, shame, and even laughter—in the casual moments of everyday life. It never goes away.[11]

The veterans' art does not, for the most part, focus on laying the blame for their experiences, but on the experiences themselves. There are, to be sure, terrible images of atrocities on both sides. John Wolfe's 1986 *Incident near Phu Loc* (fig. 47) introduces the whole cast: three young GIs, one Black, stand over a nude, spread-eagled Vietnamese woman, bound with the remains of her black pyjamas; one at least is contemplating rape; one at least is extremely doubtful and confused. They confront three Buddhist monks at the woman's head, holding up a picture of their god; the drama is arbitrated by an ARVN soldier. This is only a part of the war, but it is a part not likely to be forgotten, as the veterans themselves begin to look unflinchingly at their actions:

It became a game between the Communists and ourselves to see how many fingers and

Fig. 47. John Wolfe, *Incident near Phu Loc*, 1986 (cat. no. 107).

ears we could capture from each other. . . .
I collected about 14 ears and fingers. . . . It
symbolized I'm a killer. And it was, so to
speak, a symbol of combat type manhood.
. . . What could I do? I was some gross
animal. That's how you're trained. We
killed everything that moved. . . .

The same day I left Vietnam, I was standin'
back on the corner in Baltimore. Back in the
States. An animal. And nobody could deal
with me. . . . But my Mom, she brought me
back 'cause she loved me. . . . She kept
reminding me what kind of person I was
before I left. Of the dreams I had promised
her before I left. . . . And she made me see the
faces again. See Vietnam. See the incidents.[12]

Atrocities occurred on both sides; the fear too
was non-partisan. In Karl Michel's ghostly *Loom-
ings*, 1983 (fig. 48), a mutilated and disembodied
head hovers red in a yellow sky. Some of the vets'

works are powerful if grisly reminders that, while
American guilt tended to focus on GI and ARVN
atrocities, there were Viet Cong and NVA abuses
as well. One subject practically invisible in art is
the POW and the MIA. The latter has become an
ideological issue forced from the right, despite the
likelihood that few, if any, survivors are still in
Vietnam, Rambo notwithstanding.[13]

Theodore Gostas was a POW in North Viet-
nam from 1968 until he and 589 others were
brought home in March 1973. His small, inten-
tionally crude, and deeply felt paintings, now in
the Air Force Collection, overflow with the au-
thentic horror of his experience as a POW in North
Vietnam from 1968 until 1973. *Solitary Confine-
ment: Insects Witness My Agony*, 1982 (fig. 49)
shows a bleeding prisoner handcuffed, in stocks,
cramped inside a black square, while below, a line
of five huge black cockroaches—stick figures
reminiscent of ancient cave drawings—bear

Fig. 48. Karl Michel, *Loomings*, 1983 (cat. no. 60).

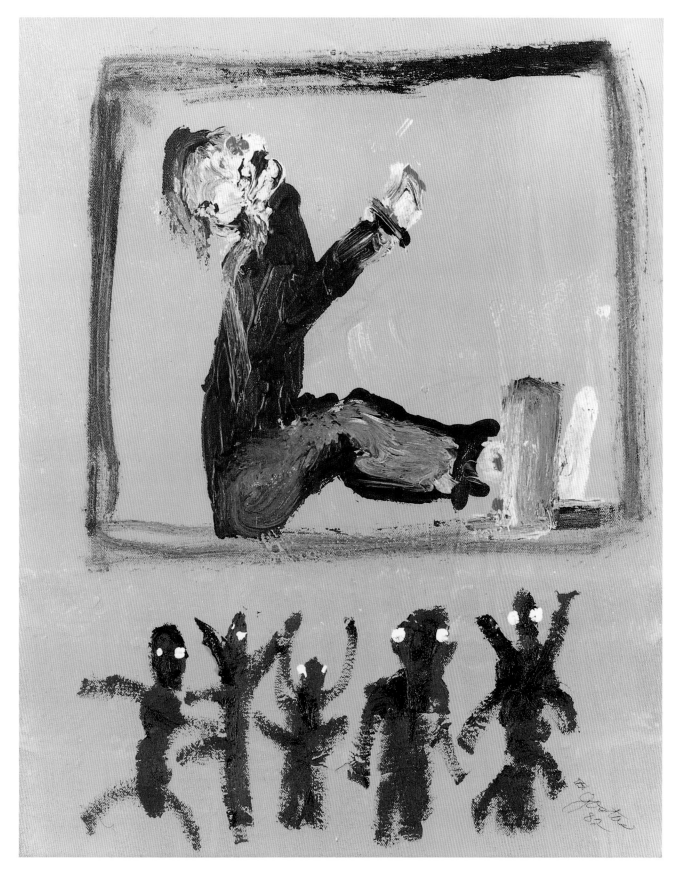

Fig. 49. Theodore Gostas, *Solitary Confinement: Insects
Witness My Agony*, 1982 (cat. no. 34).

witness. In *East is East*, 1982, a small soldier, gun erect, is dwarfed by a giant stone Buddha's head. The artist explains that this "is a classic confrontation of western army with eastern mystical aura," and cites Kipling's "East is East and West is West, and never the twain shall meet."[14]

Much veterans' art, however, is gentle, regretful, or grateful for friendship and family. There are many paintings of buddies supporting each other in pain, play, or death. There are sympathetic pictures of Vietnamese civilians enduring even greater suffering. A number of artists, vets and non-vets, have turned to the pieta image, with the places of both Christ and Madonna taken by GIs—dead, wounded, mourning, terrified. In Michael Page's beautifully executed wood sculpture *Pieta*, 1980 (fig. 50), a helmeted, hooded GI cradles in his arms a dead Vietnamese baby. The soldier's face distinguishes this work. He bears the expression of a man who has just understood the horror of his position and the trap he is in, along with his enemies. It is an expression of fear and mourning taken beyond this historical moment.

Cleveland Wright's *We Regret to Inform You*, 1982 (fig. 51), is a deeply moving depiction of a poor Black mother in North Carolina weeping at her kitchen table. She is wiping her eyes with a blood-red handkerchief, a letter from Vietnam held limply at her side. It is the only picture I know that acknowledges this part of the war; it does so with immense tenderness and simplicity, stripping the event of all melodrama.

Although during the war there were plenty of women artists contributing typical antiwar work to various shows and protests, few have approached the subject from within a female consciousness, or from their own experience. Though there were images of brave and victimized Vietnamese women, there was a conspicuous absence of waiting or mourning American mothers, sisters, wives, friends, and daughters of combatants. They were as invisible as the women— mostly army nurses—in Vietnam. So we must depend on the women's own testimonies to fill this gap:

> When we learned that our son had been killed, I was filled with terrible anger . . . I wondered if the government had done everything possible to save him. We never could get accurate information. . . . As time passed, I became determined to make some good come of what I thought was evil. All my efforts were turned toward serious questioning of my former values. That led to activism on my part.[15]

> During the Christmas bombings, my children were sent home from school. Their classmates were taunting them, saying, "Your father is a killer." What do peace people want me to tell my children, that their father died in a bad war? That he died for nothing?[16]

> How does one erase the memories of what happened when I dared to become involved in trying to end the war—my son's grave dug up, my car filled up with garbage, my little girl needing a body guard because she was shot at . . . the final humiliation of being locked out of

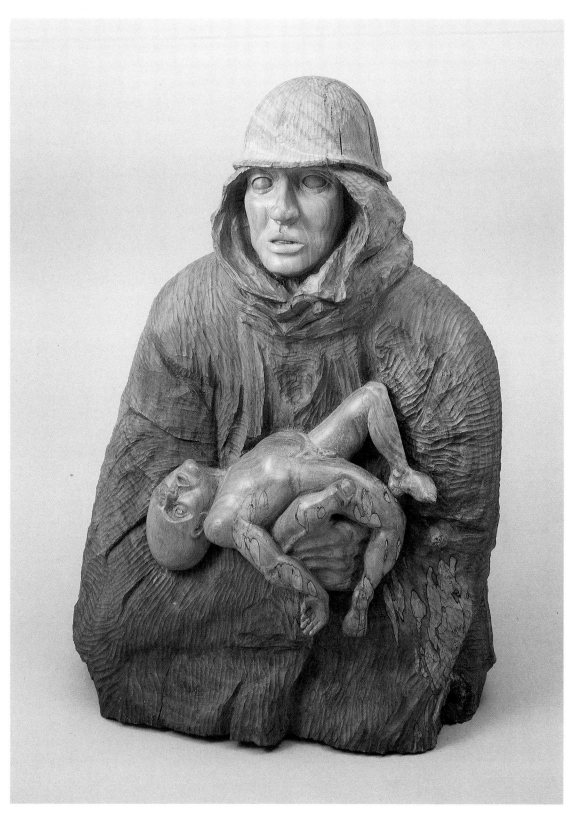

Fig. 50. Michael Page, *Pieta*, 1980 (cat. no. 65).

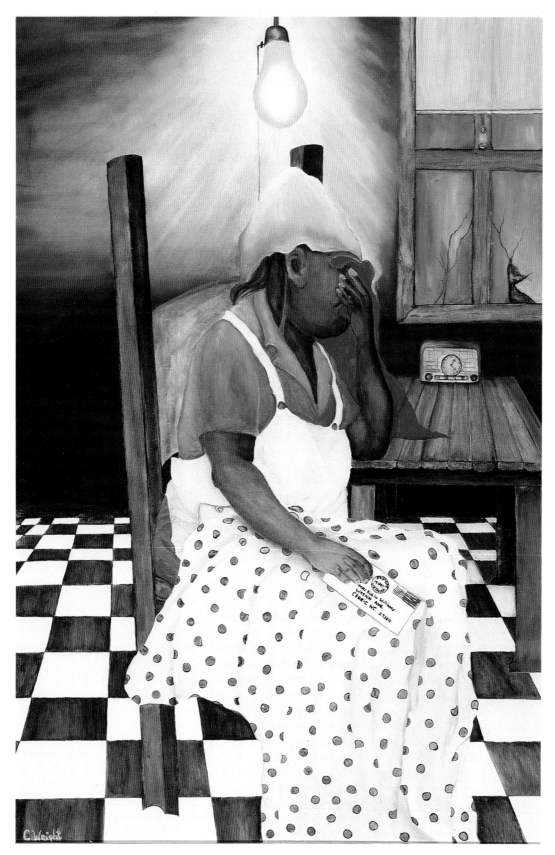

Fig. 51. Cleveland R. Wright, *We Regret to Inform You*,
1982 (cat. no. 108).

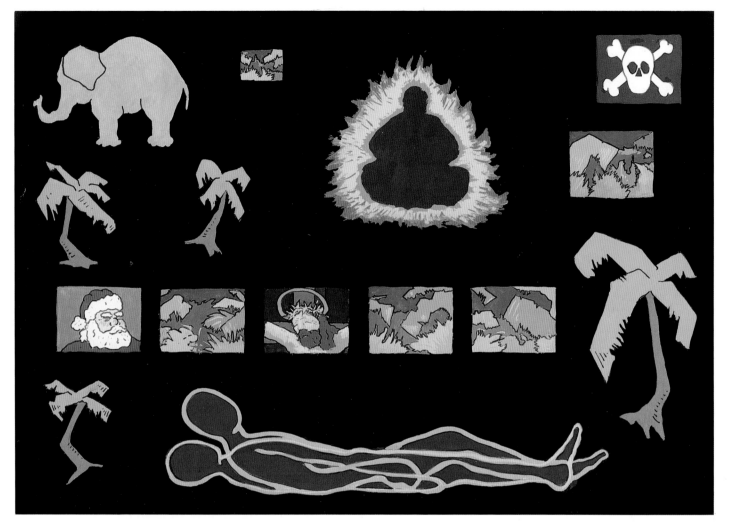

Fig. 52. John Knecht, *Aspects of a Certain History*
(Shooting Gallery) #1, 1983 (cat. no. 56).

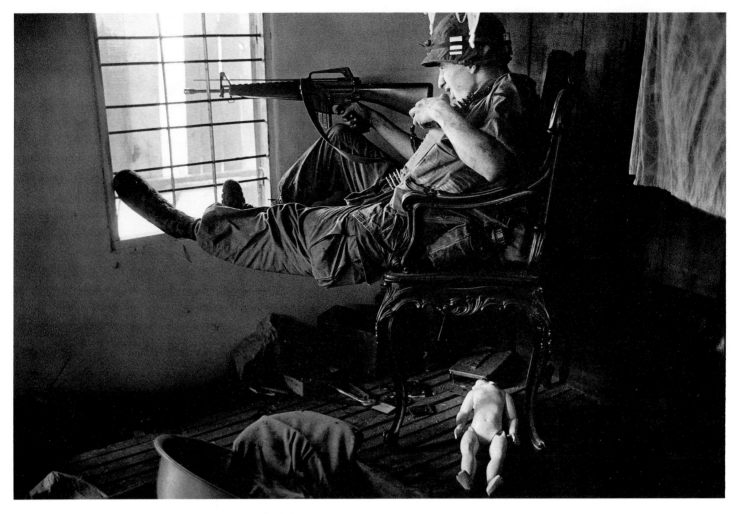

Fig. 53. Philip Jones Griffiths, *Urban Warfar—Saigon*, 1968 (cat. no. 40).

Arlington Cemetery on Richard Nixon's orders when I went there to lay a wreath in memory of our American dead in Vietnam . . . because I was one of them, the ones who dared to say that war is wrong.[17]

John Knecht, an artist and vet who teaches at Colgate University, permitted Vietnam into his art when he discovered in the early '80s how little his students knew about the war. Active in the anti-war movement after his return from Vietnam, he became alarmed when he found that only five percent of his students had studied Vietnam in high school, and then only for one class session. He saw them "ripe for the military plucking, ripe for another debacle, this time in El Salvador,"[18] so in 1984 he made a film called *A Certain History*. An hour long, it contains no war footage, focusing instead on a bucolic midwestern farm landscape. Employing an experimental form unlike any conventional documentary, Knecht presents a sequence of tableaux representing history from 5000 B.C. in Asia to the invasion of Grenada. He

jolts expectations by foregrounding the good and allowing the evil to build as undercurrent.

When Reagan's re-election triggered new anxieties, Knecht made a mixed-media installation called *Abusive Amusement*; it followed the 1983 *Aspects of a Certain History (Shooting Gallery)*. Both were based on gouache drawings (fig. 52). The latter included film, video, and newsclips with a painted jungle fantasy inhabited by repeated images of skull and crossbones, the devil, the head of a crucified Christ, a dead clown (standing for the soldier-victims), and Santa Claus (a symbol of Western justice, "the guy who knows who's naughty and nice"). The set itself was handsome and decorative, almost cheerful, animated by flashing projected images and video, including a Vietnamese woman, Marx, Ho Chi Minh, an immolating monk, a helmeted GI, and the U.S. flag. The jungle remained, while the war flickered on and off.

Peter Marin has chastised intellectuals for not listening to the Vietnam vets, for not reaching "a

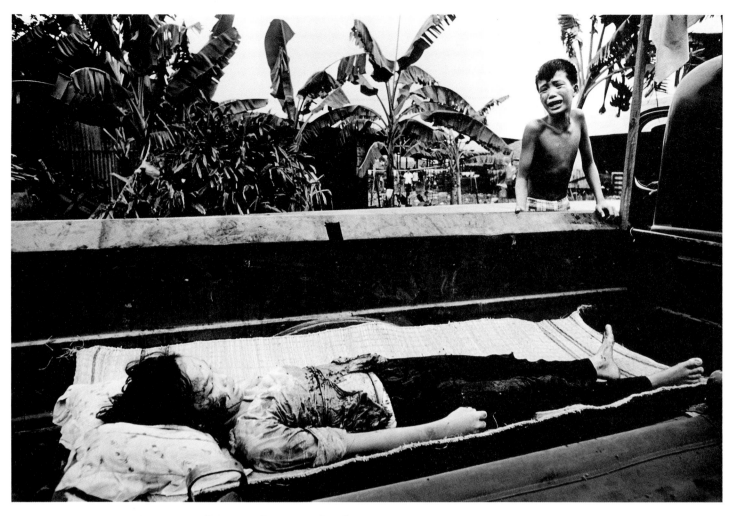

Fig. 54. Philip Jones Griffiths, *Boy Crying over Dead Sister*, 1968 (cat. no. 38).

context for what they feel." Works like Knecht's and Dan Reeves's *Smothering Dreams*—a profoundly beautiful and disturbing videotape about children playing war—offer a bridge between experience and analysis that is the arts' major contribution to healing these wounds. In his truly humanist homage to veterans, Marin attributes their heightened sense of moral complexity to the fact that they have lost "the myths that ordinarily protect people from the truth" and have in the process gained a "capacity for generosity . . . as if there were still at work in them a moral yearning or innocence that had somehow been deepened, rather than destroyed by the war."[19]

A large part of the process for restoring this context has been played by photography, film, and video.[20] Philip Jones Griffiths's excruciating pictures were taken when the Welsh photojournalist, now the head of Magnum photo agency, worked in Vietnam from 1967 to 1971. His book *Vietnam Inc.* was published in 1971 (figs. 53, 54). Griffiths is far more than an action photographer;

his many-toned response to combat and to those who directed it, as well as to what was left of civilian life, evoke both empathy and formal admiration. Some of his photos are virtually unbearable—gruesome or heartrending or both. Others convey the terrifying sweetness of life under any conditions. His captions are cryptic comments that expand from the images' specificity, e.g., "It is estimated that more dogs than wives have been taken back to the U.S. by returning GIs," and for a view of the flattened city of Ben Tre, the American general's Strangelovian claim, "It became necessary to destroy the town in order to save it." (Yet Griffiths says too that "the overwhelming impression afforded by Americans in Vietnam is one of stupidity rather than evil.")

In the same book, Griffiths cites a poem by Kim Van Kieu as "a veritable handbook on the Vietnamese psyche"; a heroine says, "It is better that I should sacrifice myself alone/It matters little if a flower falls if the tree can keep its leaves green." In one passage that echoes the

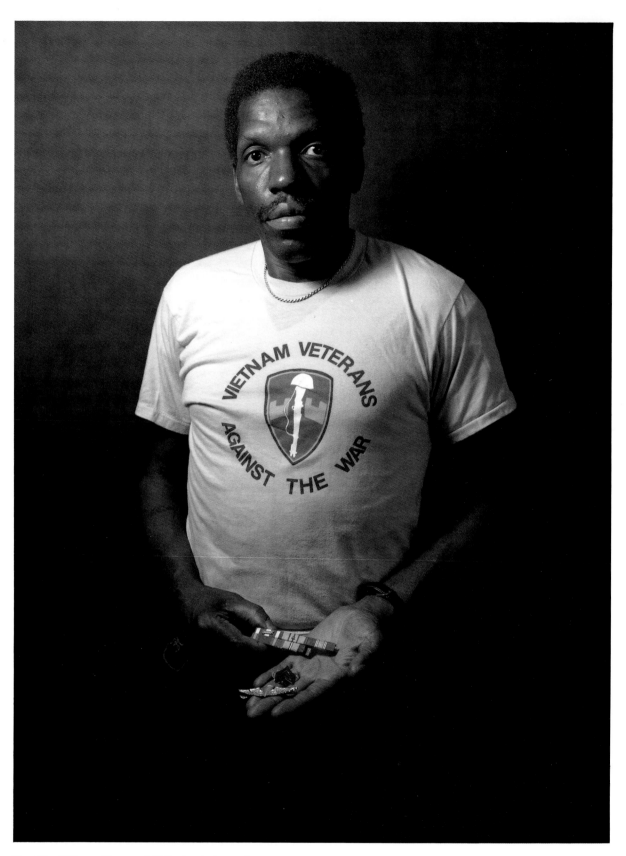

Fig. 55. William Short and Willa Seidenberg, *Clarence Fitch*, from "A Matter of Conscience: Resistance within the U.S. Military during the Vietnam War," 1988 (cat. no. 84).

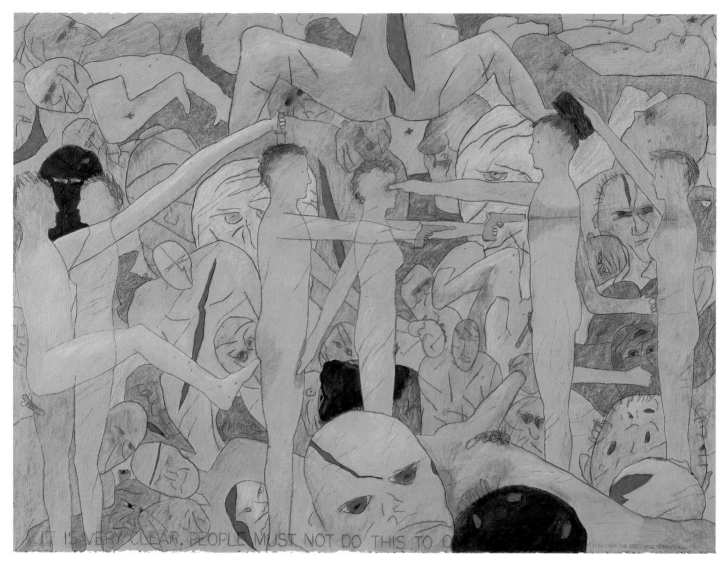

Fig. 56. David Schirm, *We Must Not Do This to One Another*, 1983 (cat. no. 83).

Vietnamese-made war film *Karma*, he notes how

> the presence of GIs has served to emasculate Vietnamese men. They have been relegated to the roles of pimp and procurer and as a result they have the greatest contempt for the wives, sisters, and daughters whom they sell so readily to the GIs.[21]

William Short, a painter and photographer, has used both mediums to advantage in his art about Vietnam. He is the only veteran to devote a large part of his work to communicating the issues of resistance to the war within the military.[22] Short had entered the service as one of those "naive" recruits who wanted to defend his country. He had several months in combat as a sergeant before he decided that what was going on was morally unacceptable. He refused to continue, and was jailed and court-martialed. Re-

turning to the States, he joined the antiwar movement but didn't mention his lurid past. He felt like a double pariah, alienated both from the vets whom he had "abandoned" and from the protesters who knew so little about the war's realities. It was years before the situation in Central America led him to confront his Vietnam experience in his art.

In the early '80s, Short did a series of vertiginous staged self-portraits in which he photographed himself, dressed in khaki and combat boots, trying to escape from a "box" outlined by red string: he tries to climb out, hides behind his court-martial papers, fends off an attacker. Transferring his Vietnam emotions to a white-walled context, he attempted to isolate and exorcise them. He also made a series titled "Of Men and Boys: Naive Paintings," which he combined in *Play for C.A.*, a multipartite wall installation

splattered with blood. In these dark, encrusted paintings, Short began to incorporate memorabilia of his own ordeal, as well as evocative elements like a black skull, old photos, and dried grasses. There is an archaeological and almost ritual aspect to much of this work. Sometimes the Vietnam reference is virtually invisible, but, he says, "the metaphor is always there."[23]

In the mid '80s Short helped organize Artists Call Against U.S. Intervention in Central America in Los Angeles. He began to work with veterans' organizations, and after moving to Boston he became active in the Smedley Butler Brigade—a group of vets that uses poetry, photography, music, and video to get its message across to high school students, among others. Since 1986 he and journalist Willa Seidenberg have initiated a vast and invaluable project called *A Matter of Conscience: Resistance within the U.S. Military during the Vietnam War* (fig. 55), documenting the unprecedented resistance that took place within the armed services during the Vietnam war—in the U.S. and in Vietnam.

Each veteran in the project is heard in a typed interview excerpt and seen in a photo portrait with a stark black background holding something personally significant, such as a father's World War II medals, a dissenting publication, a fatigue shirt. Short himself is seen with his court-martial papers (which often turn up in his work as the ultimate result of defying authority) and a knotted Vietnamese rosary with a peace symbol hanging from it; this replaced the dog tags he left in a California church before leaving for Vietnam.

David Schirm's modest but powerful wax

and oil drawing series from 1983–84 combine feathery handwritten texts with images curiously gentle in tone despite their realistic subject matter. Formally inventive, peopled by ghosts, they are nevertheless true to their base in experience, and they are rare for their constant and sympathetic inclusion of Americans and Vietnamese, their view of war as a separate, senseless force sweeping all humanity in its wake. In one drawing, death as a faceless white blob embraces a Vietnamese soldier holding a family photo in his hand (inscribed "The Angels had other plans for him but not for his family") while a white soldier (inscribed "O Lucky Man") looks on and bombs burst across the page in endless squiggles. In another, a soldier (a self-portrait) sleeps in the field near the corpses of a woman and child, while the war's spectacular fireworks light the sky. *We Must Not Do This to One Another* (fig. 56) is a chaos of nude figures of different races attacking each other with guns and knives, dominated by four large masks, an unidealized version of Pollaiuolo's *Battle*. *Visions Fill the National Cemeteries* is almost abstract, and is inscribed:

> Jumbled veteran that I am, I had to laugh . . . when Ingrid came out of her editor's office dressed in her urban guerrilla outfit. Did she ever sleep in the rain? Did she ever feel the pain? I am still angry but it's funny anyhow.

Jack Chevalier's *My Vietnam*, 1987–88 (fig. 57), also suggests forces out of control, for which the artist seems to try to find an order, if not a reason. A stormy sky divides into a patch of blue over a band of white crosses on a green field, the

lower ones edged in red and leading into the bottom third of the painting, where a helicopter, a plane, and a small, mysteriously transcendental red triangle hover over a ferris wheel. The canvas recalls a passage from war correspondent Michael Herr's jolting book *Dispatches*:

> Maybe you couldn't love the war and hate it inside the same instant, but sometimes those feelings alternated so rapidly that they spun together in a strobic wheel rolling all the way up until you were literally high on War, like it said on all the helmet covers.[24]

Some veterans have rejected first-hand imagery, separating themselves from the action by using the same still pictures circulated by the mass media and appropriated by non-vets. Prime among these recurring communal memories is Eddie Adams's image of the public execution of a Viet Cong suspect by then-chief of the South Vietnamese police General Nguyen Ngoc Loan. John Wehrle, a vet working in California, used the Adams photo to comment on the media's shortcomings in a 1987 installation of fourteen small painted wooden TV sets, alternating scenes from two narratives; the Loan shooting and a detergent commercial. *Booby Trap TV*, from the same series, is a TV haloed in barbed wire with its deadly guts of film exposed, surrounded by dominos. *Saigon Managua*, 1987 (fig. 58), is topped by a hammer and sickle and rotates between the two faces of the Communist Menace —a Vietnamese peasant and a Nicaraguan campesino, each seen as the target of a rifle site.

There is a tinge of justified madness in the strongest work by Vietnam vets. The war did not lend itself to rationality or even rationalization. Kim Jones, for instance, has chosen to embody the Vietnam experience in his own persona, as the Mudman (fig. 59), with mud-caked boots and body-stockinged face and an extraordinary sculpture—a bundle of bound and bristling sticks—jutting from his head and back. Jones is a living memorial to the continuing burden of the Vietnam War. He appears unannounced on the streets of cities, at the Vietnam Memorial in Washington, at art galleries and performance venues. He sat for a month in the window of the New Museum in New York—a tableau of resignation and reminding.

The Mudman also appears in Jones's cluttered, catastrophic large-scale drawings and other works, such as *Little Marine*, 1988 (fig. 60), a hanging sculpture of charred wood and a tangle of twigs in which the figure is almost lost. He is a "primitive" figure, representing war. He is the anonymous veteran risen from the dead to nudge the American memory, a Lazarus who recalls, as writer Steve Durland has observed, not the politics of the war but the experience of war.[25] Although there is nothing about his appearance that directly points either to war or to Vietnam (I knew his work for years before I got the connection), the reference is immediately clear to some who have shared that experience; one man came up to Jones in the street and told him tearfully "I know about war too."

Jones's performances deal with self-mutilation. He says he is "taking the war to hell with me," adding "there was a lot of mud and

Fig. 57. Jack Chevalier, *My Vietnam*, 1987–88 (cat. no. 17).

Fig. 58. John Wehrle, detail, *Saigon Managua*, 1987 (cat. no. 103).

Fig. 59. Kim Jones's "Mudman" performance, Los Angeles, 1978.

Fig. 60. Kim Jones, *Little Marine*, 1988 (cat. no. 53).

anger."[26] He once burned live rats on stage. He uses his own feces, dealing ritually with the taboos the war evokes. (Blood and shit were also poured on draft records by those protesting the war at home.) As the wandering war criminal, or victim, Jones is a shaman performing a ritual exorcism that cannot, finally, erase the collective burden of guilt. The Mudman presents a deeply disturbing spectacle to compete with those who prefer to sanitize the war in retrospect.

We may not enjoy it, but those vets who share their nightmares with us through the ultimately healing vehicle of art are being more generous than we may deserve. Peter Marin attributes the veterans' "moral seriousness, which is unusual in America," to "the fact that it has emerged from a direct confrontation not only with the capacity of others for violence and brutality, but also with their own culpability, their sense of their own capacity for error and excess."[27] They are asking us to share their responsibility. In 1986 several Vietnam vets fasted on the steps of the Capitol to stop the contra war in Nicaragua. One of them, Brian Willson, said:

> When I came back here to Disney World, after bombing shit out of another culture, I didn't want to talk to anybody because I didn't think I could communicate the rage I felt. Later I realized that if vets were to heal, we had to be very honest about Vietnam, we needed to come to terms with forgiveness, atonement, and reconciliation. Twelve vet friends of mine have committed suicide. It's hard to live a "normal" life in a society that seems insane. We walked point for our violence and now we are prepared to walk point for our healing. The veterans I work with have an incredible compassion and vision for a changed world. They are ready for a revolution of consciousness.[28]

Others commit themselves through art. The Veterans Ensemble Theatre Company likes to perform for the homeless because such a large number of the male homeless population—forty percent—are veterans; about one-third are Vietnam vets. "We use art as a way to come home to America," says the Ensemble's artistic director, Tom Bird. "Homelessness is the Vietnam of the '80s,"[29] an insight that also informs Sue Coe's painting *War Train* (fig. 74). Still others are simply clear that they should do what they can to fend off a repetition of the war. As one vet who has revisited Vietnam put it, "I sure don't want to be touring downtown Managua in ten years wondering why we napalmed these people."[30]

"NEVER HAPPEN"[1]

IN RETROSPECT

Out in the street [back in the U.S.] I couldn't tell the Vietnam veterans from the rock and roll veterans. The Sixties had made so many casualties, its war and its music had run power off the same circuit for so long they didn't even have to fuse. The war primed you for lame years while rock and roll turned more lurid and dangerous than bullfighting, rock stars started falling like second lieutenants; ecstasy and death (and of course and for sure) life, but it didn't seem so then. What I'd thought of as two obsessions were really only one . . . Freezing and burning and going down again into the sucking mud of the culture, hold on tight and move real slow . . . Vietnam Vietnam Vietnam, we've all been there.—Michael Herr.[2]

In the arts Vietnam has been a time bomb. Recent art about the war is as powerful, though different, as that made during the war, reflecting not only the psychic and political complexity of the experience but its incorporation into everything that has happened since. In an ahistorical nation, we can not only thank the memory of Vietnam for preventing a full-scale invasion of Central America but we can thank Central America for not letting us forget Vietnam. If Vietnam is more welcome as fiction (through movies, novels, TV miniseries) than as fact, and if the Iran-Contra scandal was so incredible that it sounded like fiction, at least the confusion of fact and fiction is coming partly unveiled.

It was about nine years after the 1973 cease-fire, and six after the "Day of Shame" when Saigon fell, that art about Vietnam—by both vets and non-vets—began to attract attention, breaking a period of almost total silence on the subject. The election of Ronald Reagan, who had been the hawkish governor of California during the war, and his aggressive policies in Central America served to wake up a number of slumbering '60s activists, mobilized in turn by those who had not slept. In the veterans' community, shame had given way to rage as their conditions worsened and remained unrecognized. The belated array of ticker-tape parades did little to allay their sense of anger and betrayal.

In May of 1981 Maya Lin's design was chosen for the Vietnam Memorial in Washington (fig. 61). When completed in 1982, this simple, low-profile, V-shaped wall of polished black granite, backed by the earth itself, listed the 58,135 U.S. casualties in chronological order of their deaths. Lin—who was chosen anonymously and turned out to be a young Asian-American woman, still a graduate student at Yale—said she "wanted to return the vets to the time-frame of the war, and in the process, I wanted them to see their own reflections in the names."[3]

The controversy surrounding this impressive, eminently accessible, and modernist work has been recounted in detail by Elizabeth Hess.[4] Lin's monument was initially praised as apolitical but soon came to be viewed by many as subversive. Tom Wolfe called it a "ditch of shame," "non-bourgeois art." Phyllis Schlafly called it "a tribute to Jane Fonda." Other epithets included "tombstone," "a wailing wall for anti-draft demonstrators," "a black gash of shame," and "a black spot in American history." The "gash" had unmistakable, even mythical, sexual connotations,

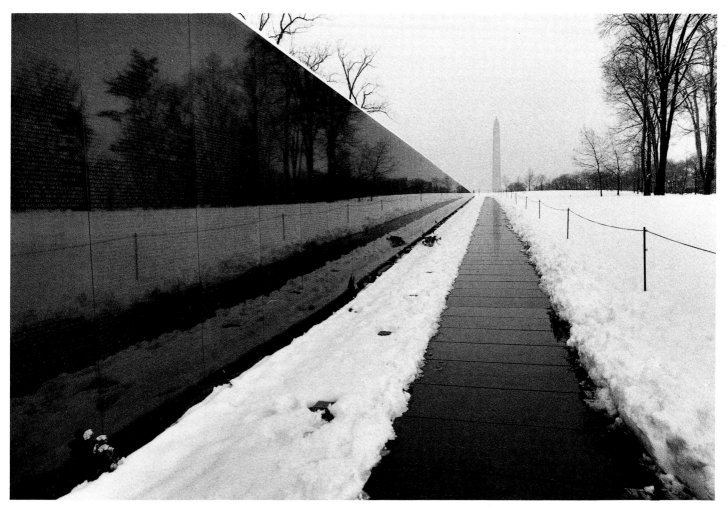

Fig. 61. Maya Lin's Vietnam Veterans Memorial,
Washington, D.C., 1982.

Fig. 62. Athena Tacha, *Model for Vietnam, Laos, and Cambodia Memorial*, 1983–84, white concrete and photo-sandblasted documentation, courtesy of the artist.

while the V-shape was associated with the antiwar victory sign, co-opted by Richard Nixon. Black was erroneously labeled by veteran Tom Carhart, "the universal color of shame, sorrow, and degradation in all races, all societies worldwide."[5] The memorial was eventually countered, ineffectively, by a small idealized sculpture by Frederick Hart. Three over-life-size bronze GIs now stare wistfully at the reigning monument from a nearby grove of trees; a similar bronze of a GI woman is planned.

Vets themselves have come to see the memorial with all the ambivalence of the war itself and its ongoing reverberations (or reflections) in American society. Some wonder if "you can honor the warrior without honoring the war." Despite the strength of personal feelings, they insist that emotions must be separated from "meaning on the larger stage of what the U.S. government has been doing in the world since the Vietnam war and continues to do today."[6] Some see the memorial as one more step in the rewriting of history, along with the "Honor the Vietnam Vet" and "Welcome Home" events, which the majority of veterans from across the political spectrum perceived as too little, too late. For most, however, the memorial is a deeply effective and affecting monument to the senseless deaths of over fifty-eight thousand soldiers. "Nobody can tell me what it means," said one vet, " 'cause I feel what I feel when I'm there."[7]

Across the United States, there are now many other Vietnam memorials, and still more are on the drawing board. They tend to repeat the dichotomy in place in Washington with the Lin/Hart face-off, ranging from modest natural boulders at isolated intersections to the grandiose counterparts of equestrian statues. There is even a miniature portable replica of the Washington Wall. Three recent proposals expand the potential meaning of such monuments. In Berkeley, rock star Country Joe McDonald has been helping to plan a monument in honor of all war dead, including those in Vietnam and those who died resisting at home. Public artist Athena Tacha, working in Ohio, has exhibited a model that combines the monumental clarity of Lin's work with the graphic specificity Hart failed to achieve (fig. 62). Dedicated to Vietnam, Laos, and Cambodia, it is envisioned as "a huge chasm, a desolated and split land." Within the arid white cliffs of the sculpture (white is the color of mourning in Vietnam) would be rows of huge and haunting news photos sandblasted into the walls. A trip through this canyon (the form was suggested by natural rock formations) would be a nightmarish journey back through reality, rather than along a passive trail of modified nostalgia. The third monument is natural, as opposed to cultural. In 1980 vet Geoffrey Steiner sold his home and bought 100 acres of land in Northern Minnesota, where he began an ongoing project of planting a tree for every soldier killed in the Vietnam war, as well as

Fig. 63. George Segal, *In Memory of May 4, 1970—Kent State: Abraham and Isaac*, 1978, bronze with white patina, 84 × 108 × 102″, collection of Princeton University, Princeton, New Jersey, John B. Putnam, Jr. Memorial Collection.

some in tribute to veterans who have committed suicide. He is more than half way toward his goal, although he almost lost his memorial when a bank threatened to appropriate it. Other veterans and concerned local people raised the money to save it. "What we're trying to do," says Steiner, "is heal the people. This is a living memorial."[8]

The most memorialized event at home is the massacre at Kent State. (I know of no art about the killings that preceded it at Jackson State.) George Segal's 1978 *In Memory of May 4, 1970— Kent State: Abraham and Isaac* (fig. 63) depicts two vaguely contemporary-looking figures, one kneeling, one standing. In a classic case of institutional squeamishness in the face of any harsh reality, it was rejected by the university as late as 1978. It seems preposterous that biblical allegory was perceived as radical, but Segal's vision clearly struck too close to home for a university that had invited the National Guard onto its campus to "defend" it from its own charges, becoming in the process quite directly responsible for the murders of four young people when the nervous, also young, guards opened fire on the demonstrators.

Kent State lost another major artwork when it refused the gift of Peter Gourfain's *Kent State Doors* (fig. 64) in the early '80s. These huge wood-framed ceramic-sculpted doors, inspired by Ghiberti, were executed by Gourfain in collaboration with faculty and students when he was a visiting artist at the university. Each clay panel is an interpretation of a scene related to the murders, with Gourfain's own intense, neo-Romanesque style setting the tone.

Richard Posner's recent proposal, illustrated in his drawing *Kent State Memorial Proposal*, 1986 (fig. 65), has little chance in such a climate. He suggests a vast but subtle earthwork on the open field where the massacre took place. It would be the shadow of a B-52, visible year-round in grass and snow, a quietly menacing phantom of war hovering over future generations of students. A conscientious objector during the Vietnam era, Posner has executed a 900-square-foot glass hearth for the Veterans Administration Medical Center in Seattle. Over a flickering fire, shuttered panels transform an image of soldiers going off to war into farmers sowing a field with a ploughshare wrought from swords.

Few mainstream artworks have offered a right-wing version of the war. Even Roger Brown's *Vietnam Commemorative* of 1982 (fig. 66) is somewhat ambiguous. One silhouetted officer figure kneels before another (a reference to sacrifice oddly reminiscent of Segal's *Abraham and Isaac*) against a series of lumpy metallic gray modules that might be read as the Wall, broken by Brown's typically stylized palm trees. A red Volkswagen bug—the quintessential symbol of the '60s counterculture—enters from the left, laying blame on antiwar protests for sacrificing the lives of American soldiers (the kneeling figure) to the North Vietnamese (the standing figure). Brown considers many of his paintings "political," although neither right-wing nor "all that tired left-wing existential bullshit." "It's just my view, like I was some old farmer sittin' on a fence rail talkin' about how things are in the world."[9]

The dedication of the Vietnam Memorial in October 1982 has come to be seen as a turning

Fig. 64. Peter Gourfain and the faculty/students of the summer sculpture program at Kent State University, 1980, *Kent State Doors*, 1980, oak and unglazed terracotta, 108 × 72", courtesy of the artist.

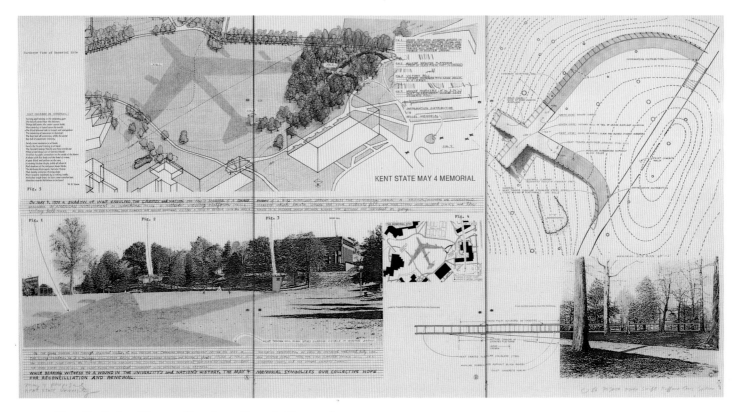

Fig. 65. Richard Posner, *Kent State Memorial Proposal*, 1986 (cat. no. 69).

point, when social amnesia about the war began to reverse—a moment when artists in prose, film, and visual arts began to let their memories out of the closet. The incredible flood of books on the war—fact and fiction, by scholars and participants—has no doubt been the most effective jogger of these memories. Thousands of poignant photographs document the responses of visitors to the Wall and the various rituals performed there by families and veterans across the political spectrum. The immense collection of notes, photos, and objects ranging from baseballs to plastic flowers to teddy bears that have been left at the Wall have been warehoused by the government, preserving an intimate dimension of the monument's extended effect.[10]

Among the many photographers who have shot the Wall and its endless variety of visitors, Wendy Watriss comes to the subject with a body of work devoted to the struggles of veterans to find peace of mind and compensation for their psychic and physical wounds. Her photographs of the Wall, from the "Vietnam Veterans Memorial" series (fig. 67), and of veterans still being killed by the war, from the "Agent Orange" series (fig. 68), are striking and compassionate. A father holds his son (one of his two children suffering from birth defects) after an Agent Orange court

decision, and a tear rolls down his cheek; two vets stand close together with their hands on a name carved on the Wall; an intimate altar-memorial to a dead soldier is created on top of the TV set in his family's home, and on the screen is a young man dead or sleeping; two buddies (ages 35 and 36, but looking far older) support each other, both wearing hand, arm, and neck braces because of muscle deterioration from Agent Orange, the dioxin-based herbicide that was widely used in Vietnam to destroy the enemy's jungle cover and has been implicated in a dreadful range of diseases, from cancers and birth defects to miscarriages and psychosis.

Watriss has visited and heard testimonies from many of those affected by Agent Orange. Approximately 245,000 people have filed for compensation in this country and over 230,000 have died in Vietnam.[11] In 1983 Watriss's series on the issue was shown in Texas with the works of Goro Nakamura (on the effects of the chemical on the Vietnamese and their land), Philip Jones Griffiths (on the process of its deployment during the war), and Mike Goldwater (on the effects of dioxins on agricultural and industrial workers in England).

A special Air Force outfit called the Ranch Hands flew the herbicide missions. Their motto was "Only we can prevent forests." Frances

Fig. 66. Roger Brown, *Vietnam Commemorative*, 1982 (cat. no. 9).

Fitzgerald has written of the American forces' monument to themselves:

> The grandest ruins are those of the American tanks, for the Vietnamese no longer build fine stone tombs as did their ancestors. . . . The U.S. First Infantry Division has carved its divisional insignia with defoliants in a stretch of jungle—a giant poisonous graffito.[12]

This image was used by long-term political activist Luis Camnitzer in his extensive etching series *Agent Orange* (figs. 69, 70). He paired the jungle scar with Robert Smithson's earthwork *Spiral Jetty*—both photographed in 1970—in an ironic comment on the art and ecological connections. Camnitzer's etchings, following a similar series on torture in his homeland, Uruguay, include highly explicit images, such as a hydrocephalic Vietnamese baby and the statement of a Dow Corporation chemist pondering in *Science* magazine the need to recast the word "teratogenicity" because of its associations with Thalidomide in the minds of consumers.

But most of the fifty pictures are enigmatic closeups of small still lifes, each eerily captioned with an ambiguous handwritten phrase that comes like a voice in a dream to ignite the understated pictures: a plastic kewpie doll on a body-like fabric landscape ("Her own harvest, too, would be different") or a castoff bolt on the ground ("Parts become useless"); an abnormally pigmented man's hand ("They gave him an ointment") or a handless watch face on a crinkled paper ("Then they waited") (fig. 70). These lyrical etchings demonstrated their subterranean power when they were shown in Berlin, Maryland, in 1986; because of threats against the building and against the artist's life, the show was prematurely closed.

William Wiley made some isolated pieces about Vietnam during the war and then returned to the subject in depth in the '80s, spurred on by links to toxic waste, nuclear war, and Central America. The 1970 *Communication Contract and Peace Tattoo II*, for instance, used his trademark sticks and stones to form a slingshot, with a presumable David and Goliath reference. In 1983 Wiley introduced a multipurpose symbol—the acoustic guitar—as persona and emblem. The guitar is associated with protest songs and Latin music; Wiley plays the instrument. Sometimes, as in *Agent Orange*, 1983, and *Agent Orange, Again*, 1986 (fig. 71), the woodblock and sculpture in

Fig. 67. Wendy Watriss, *Untitled*, from the "Vietnam
Veterans Memorial" series, 1982 (cat. no. 99).

Fig. 68. Wendy Watriss, *Dan Jordan and His Son Chad, Austin, Texas,*
from the "Agent Orange" series, 1981 (cat. no. 95).

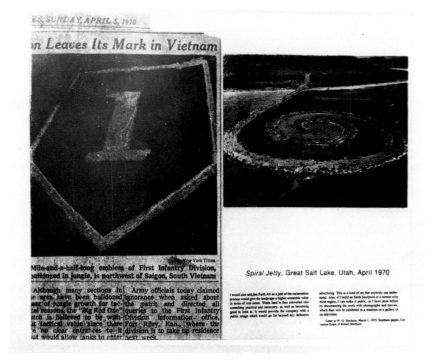

Fig. 69. Luis Camnitzer, *April 1970*, from the "Agent Orange" series, 1984, color photo-etching, 30 × 22", courtesy of the artist.

Fig. 70. Luis Camnitzer, *Then they waited*, from the "Agent Orange" series, 1985 (cat. no. 13).

Fig. 71. William T. Wiley, *Agent Orange, Again*, 1986
(cat. no. 106).

Fig. 72. Ben Sakoguchi, *Hawk*, from the "Vietnam"
series, 1979 (cat. no. 79).

this show, the guitar is a skeletal face and cross, inscribed with puns like "Agent Orange, My lie Massoak cure." In the large assemblage/installation called *Agent Orange* of 1983, the guitar lies on its black, coffin-like case at the foot of what might be a homemade grave marker. Jeff Kelley has described this major piece:

> The green and orange instrument, with its single string, will produce a distant, Oriental sound. . . . It will pluck a painful fiber in our minds. Close the case, and it will be a casket, its contents buried, stillborn and loaded in— and well beyond—the sixties. The word "Vet" is written on a small metal gong. If we "beat the Vet gong," whose funeral drum have we sounded—ours or theirs? . . . A map of Vietnam is the guitar's pick-guard. Puns aren't always fun.[13]

Retrospective depictions of veterans from the antiwar side run the gamut from hostility to compassion. Ben Sakoguchi's cheerfully dreadful 1979 "Vietnam" series is an outraged and unforgiving group of tiny paintings—black humor vignettes in which GIs are mostly evil or dumb or both. The tone of these works is curiously anachronistic—they might have been made in 1969 instead of a decade later—but their impact is not diminished. Sakoguchi has had no second thoughts, and his directness is both refreshing and applicable to other wars. He also does antinuclear subjects. A Californian, he has chosen old-fashioned orange crate labels (orange agent?) as his vehicle. Interrogation Brand (torture of Viet Cong suspects) is grown in "Westmoreland,

California"; Dinks Brand (the South Vietnamese Army) stems from "Arvin, California"; Wast'em Brand (My Lai Massacre) is from "Death Valley, California"; Hawk Brand (a quadriplegic embraced by a Beauty Queen and declaring "I'd proudly go back") is from "Rough and Ready, California" (fig. 72).

Rachael Romero's two haunting portraits of Vietnam vets from 1984 capture as no one else has the infamous thousand-yard stare by which survivors are said to be recognizable. *He Who Feels It Knows It* (fig. 73) gives the subject a modern crown of thorns—barbed wire around his baseball cap. *Vietnam Vet* relies on the headband and the wide-eyed, intense stare, a combination of terror and wisdom, to convey its empathy.

Sue Coe's 1986 *War Train* (fig. 74) shows an infernal subway tunnel with a gray procession of homeless and protesting Vietnam vets, suggesting in their angry emaciation the concentration camps (one proposed solution to homelessness), the London subway tunnels during the Blitz in World War II, and other symbolic undergrounds, bringing home not only the war, but the web of connections with other social issues that have become part of the Vietnam syndrome.

Cynthia Norton, a young woman raised on military bases during the Vietnam War, became obsessed with the subject in the '80s. In deceptively elegant formats, she paints helicopters, tanks, flags with lines of smoke for stripes. In *Madonna*, 1985 (fig. 75), she frames a hooded GI in a gold and black camouflage border like a Renaissance altar piece. His skin color is the same as that of the dead baby and, as in veteran

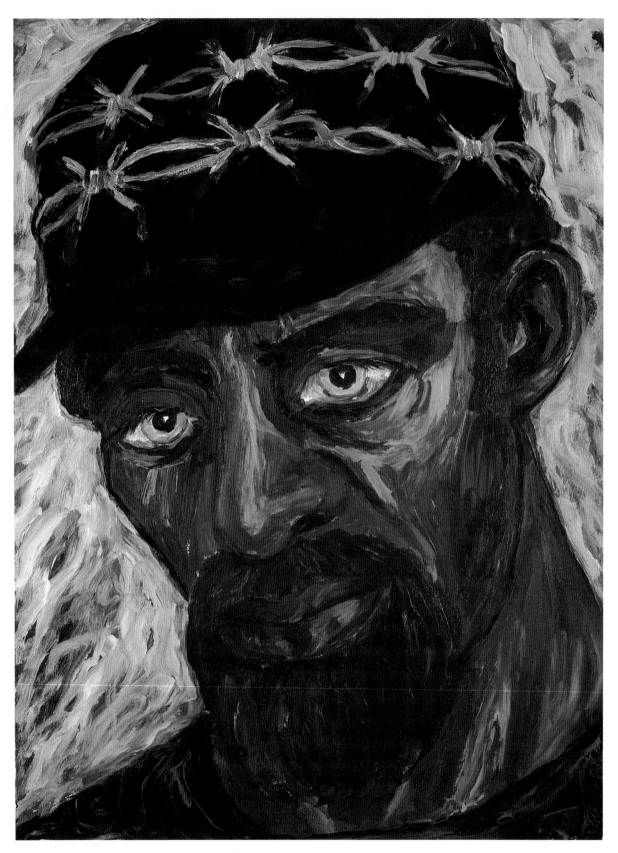

Fig. 73. Rachael Romero, *He Who Feels It Knows It*, 1984
(cat. no. 70).

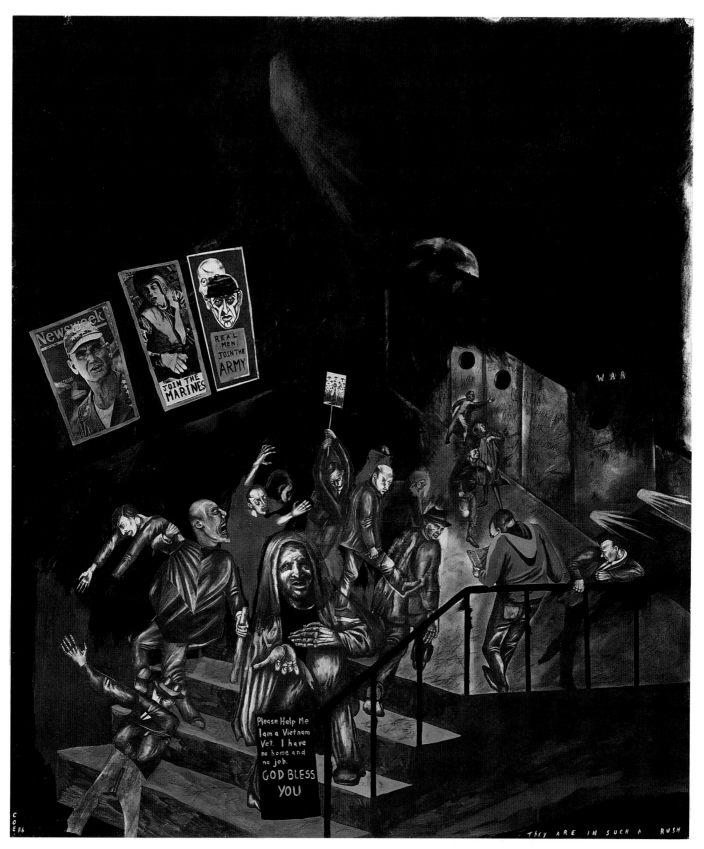

Fig. 74. Sue Coe, *War Train*, 1986 (cat. no. 19).

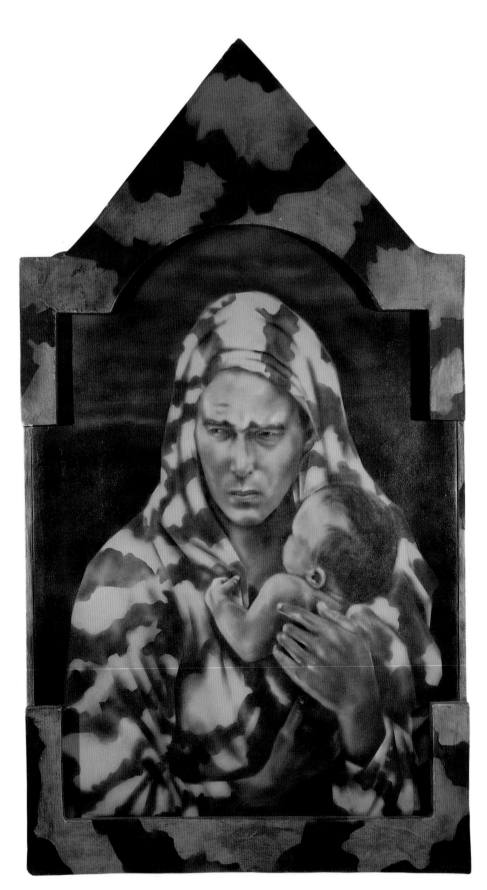

Fig. 75. Cynthia Norton, *Madonna*, 1985 (cat. no. 62).

Fig. 76. Nancy Floyd, *The James M. Floyd Memorial*, 1986 (cat. no. 28).

Michael Page's *Pieta* (fig. 50), he wears an expression of profound hurt.

Another artist who was only a child during the war has made one of the most moving recent works. Nancy Floyd's *The James M. Floyd Memorial*, 1986 (fig. 76), is a straightforward but esthetically mediated documentation-memorial to her brother, killed in action in 1969. The multipartite installation—which includes his boyish letters and snapshots, official papers, and the stone souvenir of his name from the Wall—is shown as though it were in a town hall, complete with American flag and glass cases; it brings to mind scenes from Bobbie Ann Mason's touching novel *In Country*. As one reads the young soldier's diary and letters home, as one sees him with his dog, his medal, his peace sign, and the funny, heartbreaking photo where he is curled up on his army cot with teddy bear and thumb in mouth, the very ordinariness of his death and the tenderness of his sister's art carry an impact unlike that of most images from Vietnam.

A few photographic images have become icons of the war, embedded in our consciousness of Vietnam: Haeberle's *My Lai*, Eddie Adams's *Loan*, and especially Wing Wong Ut's photograph of Kim Phuc—a little girl running down a road on a June day in 1972, naked, her arms spread, her body smoking with napalm, and on her face an expression of pure disbelief.[14] They are all images of victims. Only rarely, and usually in the poster-world of the Left, were there Vietnamese heroes in the U.S. during this war. None of these photos lend themselves to irony, which has often been the avant-garde political artist's first language and prime weapon.

In 1984, Denver artist Jim Cannata used the Adams photo in "They Killed Many of My Men" (fig. 77), which consists of seven Ektacolor photographs made by painting and then printing the negatives. By incorporating not only the well-known still but the rest of the sequence, putting the execution into a cinematic context, as the news media did not, Cannata brings the image back into real life. The unknown suspect is dragged out, threatened, shot, and carried away.

Fig. 77. James Cannata, *Untitled #1*, from "They Killed Many of My Men," 1984 (cat. no. 16).

Juan Sanchez's *It Is Beautiful to Love the World with Eyes Not Born*, 1987 (fig. 78), is a complex global palimpsest juxtaposing Kim Phuc with laughing, but also suffering, children from Nicaragua, where the same people who conducted "pacification" programs in Vietnam were supporting the counterrevolutionary mercenaries killing Central American civilians. A Puerto Rican *independentista*, Sanchez is deeply aware of the agony of such "non-wars." His painting is a rich weave of religious and political imagery with brilliant colors that underline the aura of hope that pervades all of Sanchez's art, expressed here by his title, which might paradoxically be perceived as ironic by those not as faithful as the artist. Below the altar-like rectangle, its arch a rainbow, are two hands with hearts imprinted on them, which can be read as the stigmata—the

Latino *mano mas poderosa*, the most powerful hand of Christ.

Jerry Kearns has used Kim Phuc's image three times in the '80s—first in a 1983 installation *Between Light and Shadow*, then in his 1983 painting *Hour of the Wolf*, in which Ronald Reagan swimming (up to his neck) occupies the left half of the canvas while the right is a quadruply layered image of Kim Phuc over a raging horror-comic wolf dog, an axe-bearing monster, and a barely visible row of soldiers. In the third work, the 1986 *Madonna and Child* (fig. 79), Kim Phuc's torso is imposed like a burning mask or tattoo on Andy Warhol's *Marilyn Monroe*, in a multifaceted commentary on the '60s, on our creation of heroines, fantasy "material girls," the victimization of idolized women, popular culture, the golden gloss of the American dream (in life

Fig. 78. Juan Sanchez, *It Is Beautiful to Love the World with Eyes Not Born*, 1987 (cat. no. 80).

and art), and the reality of the Third World. His 1987 painting *El Norte* (fig. 80), a "portrait" of Oliver North, refers to the connections recently exposed between heroin trade in Southeast Asia during the Vietnam War and similar charges simmering around the CIA-backed Contras in Nicaragua some 20 years later, in which many of the same people have been involved, among them Mr. North. The skulls, barely visible in the news photo behind the hooded, swaggering, covert warrior, are from Cambodia, but they might also be the ghosts of those dead on the drug-riddled battlegrounds of Vietnam and of the urban ghettos.

Keiko Bonk, born in Hawaii, sees the parentage of war another way. In her 1986 pair of paintings *Dad* and *Mom* (figs. 81, 82), she raises the flaming black peace sign like a religious icon

amid a field of skulls, and the white peace sign wreathed in thorns on a field of roses against a horizon of fire over water. This might be a reference to a hexagram of the I Ching or to Frances Fitzgerald's *Fire in the Lake*, which took its title from that source. The acrid color and raw smoky darkness of Bonk's monumental images also reinterpret the peace sign in retrospect for a postwar era that did not bring peace.

Only recently has explicit art about Vietnam's historical turmoil emerged in this country from refugees, many of whom are vehement in their support of U.S. involvement in the war. In an exhibition at Chapman College in Orange, California, in 1987, artist Richard Turner collected the work of several U.S.-trained Vietnamese artists. The younger ones, such as Chi Le, are breaking tradition with passionately expressive works. Her

1984 painting *The Butcher Shop* (fig. 83) is a lurid abstraction of not-quite identifiable body parts. Of this and other war-related works, she says:

> You feel the war has torn you apart. It pulled out my skin and my hair. Every night bombs dropped. . . . I make *Butcher Shop* because I remembered a butcher shop on a road in the country. They sold deer and other wild animals. I thought back to that, and I thought of the war. It was bloody . . . the meat of animals we eat looks exactly like the meat of people who blow up with bomb.[15]

Hanh Thi Pham, also a young refugee, struggles to maintain her own cultural identity by making labyrinthine color photographs, often of staged tableaux acted out by a multiracial cast consisting of friends, family, and her sometime collaborator Richard Turner. Amid isolated sculptural-architectural elements that suggest but never describe a splintering city, *Asking Questions of Mr. Sky*, from the series "Along the Street of Knives," 1985 (fig. 84), is the stage on which a war unlike that depicted in most Vietnam works is acted out. For all their theatricality, Hanh Thi Pham's visions ring true as a series of concrete metaphors for the stealth, intrigue, and suspense of a long battle against colonialism. A suspension bridge leading nowhere, a paper question mark, floor games, torture, prisoners, flag, monkey, masks, and cutouts all float on a black ground as though projected onto our consciousness in a movie from another world. The instability and vitality of these photographs suggest not only the atmosphere of war but of the cross-cultural experience in which the artist found herself then and finds herself now. One suspects a detailed personal iconography, a chain of meanings partially concealed from Western viewers. Yet we cannot help but be intrigued by our own parts in these pictorial puzzles.

Turner, in his role as curator and artist, has played a unique role in opening access to the Asian immigrant community. Son of a forensic scientist advising the Vietnamese police, he spent his high school years, 1959–61, in Saigon, and he maintains a deep respect and concern for Asia and its people. (He also studied in Taiwan and India.) His cleanly beautiful modernist versions

of Buddhist reliquaries, crumbling colonial architecture (or colonial structures, in the broader sense), brutal graffiti, funerary pavilions, shutters and mosquito net for mystery, broken glass, oddly serene bamboo and camouflage sculptures, and melancholy Asian gardens and hotels—all reflect the simultaneously vulnerable and protected vantage point from which he viewed the early stages of the war in Vietnam as an adolescent foreigner. Turner works most effectively in installation form, and calls his work "architectural narratives," which are often accompanied by actual narratives in book form that weave fictionalized autobiography with factualized fantasy.

In 1981 Turner made *Immolation Maze* about the Buddhist monks who set themselves afire in the late '50s and early '60s to call attention to religious persecution and the dismissal of peace efforts. In 1983, in *Reliquaries*, Turner assembled a group of red enamel cremation boxes stacked under a pavilion roof. In 1984, *The Book of the Disappeared*, with graffiti, banners, and sculpture, brought together the victims of human rights abuses in Asia and Central America. In 1985, *Coup d'Etat* recalled the unsuccessful attempt to overthrow Ngo Dinh Diem in 1960; as a high school student, Turner had gone into the streets and collected the remains of the struggle for his first sculpture—spent ammunition, blasted masonry, sandals and personal belongings left behind in the panic, and newspaper accounts.

In 1987 Turner made a very large installation—*Hotel Cô Hôn*—at the Washington Project for the Arts as part of its innovative and important exhibition on Vietnam, "War and Memory: In the Aftermath of Vietnam." Black, white, and gray, the work incorporated what seemed to be the remnants of a colonial hotel, complete with old photographs, maps, folding screens, tiles, sculpture, scrolls, two white sarcophagi, and blackboards, with scrawled messages such as "We heard the blast and saw him fly up, separate into thousands, become air. And then we were breathing him." Interior and exterior, beauty and destruction merged into an elegy for a civilization that will never again be the same.

Caesar in Indochina, 1988 (fig. 87), places the blazing white of classical plaster casts against the earthy brown of a water buffalo hide on which a map of Indochina is outlined, almost organically,

Fig. 79. Jerry Kearns, *Madonna and Child*, 1986, acrylic on canvas,
96 1/2 × 80", private collection, Merian, Pennsylvania.

Fig. 80. Jerry Kearns, *El Norte*, 1987 (cat. no. 55).

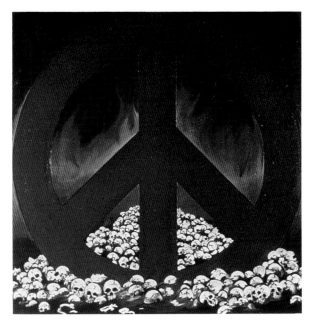

Fig. 81. Keiko Bonk, *Dad*, 1986 (cat. no. 6).

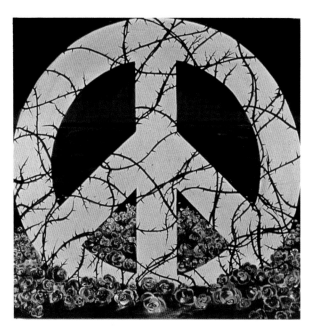

Fig. 82. Keiko Bonk, *Mom*, 1986 (cat. no. 7).

but suggesting a brand. Both images are an imposition—of white on Asian, of boundaries on nature. Turner was inspired by reading that Roman coins have been found in Vietnam, the farthest reach of the Roman Empire, providing a parallel with U.S. imperialism, and perhaps a more personal note, since Turner has had the buffalo hide since his childhood in Saigon when he too was an alien presence in Indochina. The water buffalo is the major beast of burden in Southeast Asia, and here it is hung on the wall like a trophy. Before it, however, stands the historically accurate trophy: a U.S. military canteen dangling from a bamboo cooking tripod, symbolizing the triumph of guerrilla warfare over high tech.

Postmodernism and socially concerned art have been enjoying a flirtatious and often incompatible relationship for years. The critical or deconstructive mode of Postmodern Conceptual art is reminiscent in both form and strategy of much work from the late '60s and early '70s and is fertile ground for social comment. In most cases, however, it lends itself uneasily to involved or engaged work, since its main tenet is a determinedly "objective" distance from lived experience and thus from virtually all of society's visual production. In the last decade Margia Kramer has been one of the few artists to use "appropriation" techniques to inform as well as to dissect. Using the Freedom of Information Act (FOIA) as her instrument, Kramer has exposed devious and

illegal government surveillance campaigns aimed at activists harboring such suspect principles as peace, civil rights, women's liberation, and opposition to CIA covert actions. On the trail of latent racism, sexism, red-baiting, and paranoia, Kramer has come across a good deal of material from the '60s, including COINTELPRO (the Nixon White House's "counter-intelligence program" against all those perceived as radicals) campaigns against the actress Jean Seberg and the Black Panthers.

Recently Kramer came upon data about the "lost" address books of radical lawyer William Kunstler and peace activist Dave Dellinger. "Found" respectively on the subway and on a plane, they were suspiciously delivered to the FBI instead of to the respective lost and found offices. In her 1987 work *Address Book Triptych* (fig. 85), Kramer takes the black-barred, censored documents acquired through the FOIA, photostats them on acetate, and mounts them as small three-piece "screens," reminiscent of medieval altarpieces or dressing-table mirrors. The evidence framed, and framing the viewer, incriminates not those who exercise their constitutional rights to criticize government policy, but the government itself for spying on its citizenry.

Bruce Barber's 1985–86 *Remembering Vietnam* (fig. 88) situates itself somewhere between art and criticism. He combines color photographs from the period and three panels of "propaganda" from corporate supporters of the war. Barber

Fig. 83. Chi Le, *The Butcher Shop*, 1984 (cat. no. 18).

Fig. 84. Hanh Thi Pham and Richard Turner, *Asking Questions of Mr. Sky*, from "Along the Street of Knives," 1985 (cat. no. 46).

lives in Canada (we tend to forget that Canadians, Australians, and New Zealanders also fought in Vietnam) and has produced a large body of work deconstructing the so-called "advocacy advertisements" of United Technologies, a leading producer of aircraft engines, helicopters, and other military technology, then and now. In a manner as understated as the company's editorials, Barber points out where United Technologies' agenda pokes through the ads' neutral fabrics. It is all very straightfaced and straightforward, demonstrating how the mere isolation as art of apparently harmless propaganda from the military industrial complex can expose its ideological affect and bland authoritarianism.

The United Technologies editorial on Vietnam, for instance, quotes Ho Chi Minh and avoids the issues, piously declaiming:

Let others use this occasion to explain why we were there, what we accomplished, what went wrong, and who was right. We seek here only to draw attention to those who served. . . . Those who served in Vietnam deserve better than what they got. As a nation we have always tried to do what is right. Let us try to do right by the Vietnam veteran.

Terry Allen's "Youth in Asia" project began in the early '80s and is the most extensive and most complex body of work on the war and its ramifications. Allen has taken the Vietnam experience and applied it to a vast span of contemporary American life, especially the area in which cultures cross or bang into each other. Also a musician, he calls his project "Visual and Aural Mythologies." He began at the beginning with an assemblage called

Fig. 85. Margia Kramer, *Address Book Triptych*, 1987, photostats on film in wood frames with plexiglas, 21 1/2 × 52 1/2 × 1", courtesy of the artist.

The First Day (Back in the World), its erratic pace and mixture of mediums reflecting the vertiginous return of vets from Vietnam. They were given no transition between war and the peace that was not a peace at home. "I was killing gooks in the Delta and seventy-two hours later I'm in bed with my wife—and she wonders why I was different," as one man put it.[16]

Many of Allen's works are made with sheet lead—a soft, patinaed, malleable, and symbolically deadly material. Some are extremely simple visually, pure as mourning. *Grace*, 1985, is mostly gray, black, and white; a stylized white bed with a Day of the Dead skull beneath it sits on a glassed-over map of Southeast Asia, backed by a framed night sky with a crescent moon, a bamboo cross, an Asian glyph, and the inscription "for one moment the anger is gone . . . but that's all." It is a sad, luminous work about mortality, about the distance and the familiarity of death in dissimilar cultures. Some of the same motifs appear in a very different work, *Bearing Straight at the Club Cafe*, 1984, which includes: the photo of a similar skull; a photo of a cafe on Route 66 in Santa Rosa, New Mexico; the typed text of a conversation perhaps from that cafe; a pointillist multicolored map of the Pacific and the North American and Asian continents reaching across the Bering Strait, almost touching; a real fork; and a poem. To the side is a much smaller painting labeled "the Mexican Shepard [*sic*] Boy." The boy holds a

crook and a lamb, is haloed by a burst of light, and adored by another haloed lamb.

Boogie Chillin (fig. 86) is a recent addition to this series. The vicious Dumbo (Rambo), with his teeth filed to sharp points, is a ghostly presence flying inverted across the windows of a house. In two other frames are the doorway, with a blood-red carpet leading to it, and a wall with a Vietnam service ribbon on it. The text is the entire lyrics of an old John Lee Hooker song about adolescence. It begins, "I'm a goin away baby, but I will be comin back," and continues, "Let that boy boogie woogie, he's a man now, can't hold him down. . . . Hey, jump chillin." (Perhaps the spelling of "chillin" is also a word play, given the chilling circumstances.) The effect is one of negative transformation, conveying the kind of energy and expectations that sent young men off to war and how that adventure turned out, or inside out.

Allen's art is not about being in Vietnam but is a grand design about coming home. Linking Southeast Asia and the American Southwest, he has embarked on a profoundly important journey through alienated restlessness, dislocation, and the loneliness of cultural cross-overs. The Native American and the Vietnamese are frequent protagonists, given the migration of indigenous peoples (from the Navaho to the Hmong) from Asia to North America, as implied by the "(Ka)China Night" work. Landscape, religion, time itself are also subjects. Throughout the

Fig. 86. Terry Allen, *Boogie Chillin*, 1988 (cat. no. 1).

"Youth in Asia" series, an intricate web of leaping, fleeting suggestions testify to the shifting ground beneath both war and peace.

Allen explicitly refers to drugs, alcohol, racial discrimination, and social despair in his work. He often uses Disney characters, familiar friends from another world, as iconography for imperialism, suggesting a certain childishness as well as the brutal superficiality of American culture and the disregard for deeper human meaning. (His Mickey Mouse predicts the ending of Stanley Kubrick's film *Full Metal Jacket*.) Sometimes his work is hallucinatory, hectic, like a night out of control in a honky-tonk bar. He strikes many chords. Like the rest of us, Allen is still trying to figure the Vietnam era out. In doing so, he weaves in so many sore points that seeing a show of his can literally hurt.

It is the role of the artist not merely to depict war, but to reveal its structures, its mechanisms, its history and sources. On one hand, polls as recent as 1982 indicated that "about 70 percent of the American population regard the Vietnam war not as a 'mistake,' but as 'fundamentally wrong and immoral.'"[17] On the other hand, it is frightening to see Vietnam beginning to be treated in many subtle and overt ways as just another war, a war like all the rest. This is damage control at its most insidious.

"America doesn't like losers."[18] In 1982, President Reagan counseled the nation about Vietnam: "It's time to stop looking backwards at how we got here."[19] This is an attractive proposition to many. It has led us to the point where the Vietnam Memorial, with all the painful work of remembering that has gone on around it, has become a kind of history stopper—an anti-memorial. As the rosy haze of manufactured memory settles over us, the victims of the war are forgotten, to be replaced, even in movies as "realistic" as *Platoon*, by the good old-fashioned warrior hero of our past, wallowing in male bonding and learning to kill. All of this revisionism paves the way for similar wars and interventions. It is this false image that the art in this exhibition—In Country, In the World, and In Retrospect—serves to correct.

The temptation to provide a master narrative—"this is the way it really was"—has been avoided by most artists, even veterans, even as they also try to avoid the standard representations. Paradox and ambivalence continue to mark our responses to this different war and are responsible for the uncomfortable and unsatisfying aspect of so much art about Vietnam. A detailed analysis (including race, class, and gender) of the representations of the war's protagonists is the next step in the process of its disclosure through visual art. As Edward Said has said about image-making, or "representing," any subject:

Fig. 87. Richard Turner, *Caesar in Indochina*, 1988, (cat. no. 92).

Remembering Vietnam

Vietnam occupies that part of the mind inhabited solely by memories. Our collective memories will recall that ten years ago this spring, America's involvement in Vietnam came to an end.

It is a date that will live in ambiguity. In Ho Chi Minh's own words, "The Americans don't like long, inconclusive wars—and this is going to be a long, inconclusive war." It was.

Let others use this occasion to explain why we were there, what we accomplished, what went wrong, and who was right. We seek here only to draw attention to those who served.

They gave their best and, in many cases, their lives. They fought not for territorial gain, or national glory, or personal wealth. They fought only because they were called to serve. Some returned intact, some physically and emotionally maimed. Others never returned and are immortalized in a national memorial in Washington, D.C.

Perhaps they questioned why they were there. Certainly some complained. Yet they served. Many lie today beneath white crosses or buried in our personal memories. They all were soldiers.

No one wants war—not the civil leaders who proclaim it, not the civilians who suffer from it, least of all the soldiers who must fight it. Yet we have it. In the words of Plato, "Only the dead have seen the end of war."

Whatever acrimony lingers in our consciousness, whatever regrets we may have, whatever "might-have-beens" or "if-only's," whatever people may say on this anniversary, let us not forget the Vietnam veteran.

It was on July 8, 1959, that the first American was killed in that war. For 16 years they died. Then, on April 30, 1975, the last Americans left Vietnam.

In a larger sense we all are veterans of Vietnam. It is part of our history.

Those who served in Vietnam deserve better than what they got.

As a nation we have always tried to do what is right. Let us try to do right to the Vietnam veteran. Let us begin by remembering.

Etched in granite on the face of a Vietnam Veterans Monument in Buffalo, New York, are feelings that should be etched in our hearts:

They answered when called;
Asked for little and got less;
And made us richer for their sacrifice
But poorer for their passing.
In remembering the dead,
We embrace the living.
For we ought to remember
Better than we do.

UNITED TECHNOLOGIES

"There were Vietnamese officers, enlisted men, and NCO's that were there for the wiring of prisoners. You could take the wires of a jeep battery (it's a tremendous amount of voltage), put it most any place on their body and you're going to shock the hell out of the guy. The basic place you put it was the genitals. There were some people who really enjoyed that because people would really squirm."

The Winter Soldier Investigation Into American War Crimes in Vietnam. Boston, Beacon. 1972. p114.

Fig. 88. Bruce Barber, detail, *Remembering Vietnam*, 1985–86 (cat. no. 5).

Whether you call it a spectacular image or an exotic image or a scholarly representation there is always this paradoxical contrast between the surface, which seems to be in control, and the process which produces it, which inevitably involves some degree of violence, decontextualization, miniaturization, etc.[20]

Rudolf Baranik has contended for many years now that

political art is not in competition for specificity, information, and direct "effectiveness" with mass media, with film or photography, not to mention direct political action. . . . Holding political art to pedestrian service-ability perpetuates its ghettoization.[21]

Donald Kuspit raises some additional questions:

Protest is a form of political action, but protest art is a form of interpretation of political action . . . at best a form of psychic picketing. . . . Marx contrasts philosophers who interpret the world with revolutionaries who want to change it. Is art closer to philosophy or revolutionary action, particularly political or so-called protest art? Can art in any sense be said to be a species of action?[22]

I think it can, but it must be evaluated on its own turf rather than getting caught between action and information and deemed secondary or even useless on either count. Kuspit's separation of the philosophical sphere from political action is unhealthy; in fact, art offers a bridge between thinking and doing because it is at its best a little of both, whether it remains in the galleries or gets out on the streets. Art isn't supposed to be practical, but it's great when it is.

If it is not clear precisely what art did for the Vietnam era, it is pretty clear what the Vietnam era did for art. It created a renewed sense that art can play a significant role in social change. The variety of political culture that has emerged in the last fifteen years, the employment of increasingly sophisticated esthetic and critical methods, and expanded knowledge of diverse contexts and audiences possible for art—all these are due in part to the lessons and experiences of artists who responded in so many diverse ways to the war.

IN "THE WORLD"

l. An ironic phrase first used by vets and then by civilians at home; it suggests little regret and no control over whatever disaster occurs. Each section of this text is introduced by a phrase from the pungent slang of the Vietnam grunt.

2. Norman Mailer, in "Vietnam Opinions," *Partisan Review*, Fall 1965.

3. The letter in the *New York Times*, June 26, 1962, was signed by hundreds; the 1968 letter, in *Caw* (the SDS magazine), was signed by Rudolf Baranik, Leon Golub, Irving Petlin, and Jack Sonenberg.

4. Donald Duncan, *Free Press*, Los Angeles, March 4, 1966, p. 4.

5. Max Kozloff, "Art," *The Nation*, February 20, 1967, p. 248.

6. Leon Golub, "The Artist as an Angry Artist," *Arts Magazine*, April 1967, p. 48.

7. Ad Reinhardt, in cartoon "How to Look at More Than Meets the Eye," *PM*, September 22, 1946.

8. Robert Smithson, in "The Artist and Politics: A Symposium," *Artforum*, September 1970, p. 39.

9. Gregory Battcock, in *Open Hearing*, Art Workers Coalition, New York, 1969, document #4. (The same year, the AWC also published a companion volume called *Documents I*. Copies are still available from Printed Matter, 77 Wooster St., New York, NY 10012.)

10. Ian Burn, "The 'Sixties: Crisis and Aftermath (Or The Memoirs of an Ex-Conceptual Artist)," *Art & Text*, no. 1 (Autumn 1981).

11. Art Workers Coalition, in broadside "Reply to Letters Regarding 'The New American Painting and Sculpture: The First Generation,'" June 15, 1969.

12. Jean Toche and Gene Swenson, in *Open Hearing*, Art Workers Coalition, New York, 1969, documents #1, #6.

13. Carl Andre, interview with Jeanne Siegel, *Arts Magazine*, November 1970, p. 175.

14. In December 1966 a passing policeman noticed in the second-floor window of the Stephen Radich Gallery on Madison Avenue a sculpture in which Old Glory appeared to be hung in a noose. Marc Morrel's one-man show was overtly antiwar, centered on a giant octopus in a helmet with a flag motif. Another sculpture was in the form of a cross that included a flag-wrapped penis, protesting the lack of separation between church and state (both supported the Vietnam war). Radich, rather than the artist, was arrested and convicted (though Morrel's work was again removed from "The Collage of Indignation" at N.Y.U. in 1967), and the Art Dealers Association of America refused to support him. The appeal reached the Supreme Court, which divided 4-4, because of the almost inexplicable absence of Justice William O. Douglas, an outspoken liberal who was then under threat of impeachment by the right wing. (See the clear and detailed article by Carl Baldwin: "Art & the Law: The Flag in Court Again," *Art In America*, May–June 1974.)

In 1989 another flag desecration case came before the court. Although it was not directly art-related, the flag-burning during a 1984 demonstration raised the same issues and was equally crucial to artists, a group of whom filed an amicus brief accompanied by reproductions of their work which would become illegal. This time the court determined such laws unconstitutional; flag-burning is a protected form of free speech. Nevertheless, flag-wrapped politicians immediately introduced laws to bypass the Supreme Court decision, and as of this writing, one such statute was passed by the House and the Senate on October 12, 1989, while an amendment to the Constitution to protect the flag is also under consideration.

15. When the Judson Three appealed, they were joined by Abbie Hofmann, who had already been convicted for wearing a flag-like shirt when he appeared before the House Committee on Un-American Activities. One of the AWC's retorts to the law was "Look what the U.S. Post Office does to our flag every day!" The audience at a symposium on the show on December 1, 1970, was encouraged to wear a canceled flag stamp to related events.

16. Ralph Shikes, "Political Posters: A Capsule History," *Art and Artists*, February–March 1988, p. 21.

17. March 16, 1968: Charlie Company systematically killed 583 Vietnamese women, children, and men in the village of My Lai ("Pinkville," the GIs called it) in the Song My area. The massacre was recorded by U.S. Army photographer Ronald Haeberle, but the public would never have known about it were it not for whistle-blower Ron Ridenhour, whose persistence finally bore fruit in 1969. One man was arrested, Lieutenant William Calley; Ridenhour pointed out, however, that the massacre was the result not of an individual but of policy. (See Alexander Cockburn, *The Nation*, March 26, 1988.)

"This dude, Lieutenant Calley, really didn't do nothing, man. I know, because I used to be in the field. He didn't do that on his own to My Lai. He was told to do that. We killed a whole lot of innocent gooks by mistake, because they were not supposed to be there. The GIs would take them out of their home. But dig this, the people's religion is very strong. They can't leave where they live. So I see why they would come back." (Specialist 4 Charles Strong, quoted in Wallace Terry, *Bloods: An Oral History of the Vietnam War by Black Veterans* [New York: Ballantine, 1984], p. 53.)

18. Susan Sontag, "Vietnam Opinions," *Partisan Review*, Fall 1965, p. 655.

19. Hans Haacke, interview with Mary Gordon, *Strata*, vol. 1, no. 2 (1975), p. 8.

20. See Paula Harper, *Art Journal*, Winter 1970.

21. Sean H. Elwood, *The New York Art Strike of 1970 (A History, Assessment, and Speculation)*, unpublished Master of Arts thesis, Hunter College, New York, 1982. The quotations about the Art Strike by Johnson, Petlin, Tucker, and Elwood are also from this source.

22. Kynaston McShine, "Essay," *Information*, Museum of Modern Art, New York, July 2–September 20, 1970, p. 138. That summer an Art Strike committee formed "the Emergency Cultural Government" and led a boycott of the U.S. Pavilion at the Venice Biennale. Twenty artists (including Roy Lichstenstein, Andy Warhol, Claes Oldenburg, Ed Ruscha, Frank Stella, and the Roberts Rauschenberg, Morris, and Motherwell) signed a letter, dated June 5, 1970, "denying the use of their art as a cultural veneer to cover policies of ruthless aggression abroad and intolerable repression at home." Another international action was the "Open Letter to Pablo Picasso" asking him to remove his *Guernica* (then at MoMA) from public view, in order to "renew the outcry of *Guernica* by telling those who remain silent in the face of My Lai that you remove from them the moral trust as guardians of your painting."

23. Irving Petlin, in Elwood, p. 38.

24. Max Kozloff, "Art," *The Nation*, November 13, 1967, p. 509. This is a detailed review of Petlin's "Christ in Asia" series. Cardinal Spellman's "Kill a Commie for Christ" comment also inspired a painting in Nancy Spero's "Bombs and Helicopters Series."

25. Jim Rosenquist, interview with Gene Swenson, *Partisan Review*, Fall 1965, p. 599.

26. David Schapiro, *Art in America*, May–June 1974. *Lipstick* was eventually vandalized, then removed by the artist.

27. Carrie Rickey, "Unpopular Culture (Travels in Kienholzland)," *Artforum*, Summer 1983, p. 46.

28. Nancy Spero, quoted in Jon Bird, "Nancy Spero, Inscribing Woman—Between the Lines," *Nancy Spero*, ICA, London, 1987, p. 24.

29. Nancy Spero, *Profile*, vol. 3, no. 1 (January 1983), p. 6.

30. May Stevens, interview with Cindy Nemser, *The Feminist Art Journal*, Winter 1974–75; quoted in May Stevens, *Big Daddy 1967–75*, Lerner-Heller Gallery, New York, 1975.

31. Donald Kuspit, *Leon Golub* (New Brunswick, N.J.: Rutgers University Press, 1985), p. 73.

32. Leon Golub, interview with Michael Newman, *Leon Golub: Mercenaries and Interrogations*, ICA, London, 1982, p. 11.

33. Leon Golub, *Profile*, vol. 2, no. 2 (March 1982), p. 13.

34. Rudolf Baranik, in conversation with the author, 1987.

35. Rudolf Baranik, "Conversation," in *Rudolf Baranik: Napalm Elegy and Other Works* (Dayton, Ohio: Wright State University Art Galleries, 1977).

36. Rudolf Baranik, interview with Irving Sandler, in *Napalm Elegy* (New York: Lerner Heller Gallery, 1973), p. 12.

37. In an envious and competitive art world, Morris's intense but short-lived leadership, and the publicity attached, inspired anonymous stickers that appeared in SoHo reading "Robert Morris Prince of Peace."

38. Quoted in Vincent Harding, "A Long Time Coming: Reflections on the Black Freedom Movement, 1955–1972," in *Tradition and Conflict: Images of a Turbulent Decade 1963–1973* (New York: Studio Museum in Harlem, 1985), p. 33.

39. Harding, p. 33.

40. Martin Luther King, Jr., "A Time to Break Silence," in Reese Williams, ed., *Unwinding the Vietnam War: From War Into Peace* (Seattle: The Real Comet Press, 1987), p. 436. Toward the end of his life, Malcolm X was also pointing out the relationship between the Black Freedom Movement and liberation struggles around the world.

41. Thanks to Mimi Roberts for making sure California got its due, and to Rupert Garcia and Holly Barnet-Sanchez for providing much of the information on Chicano art.

42. D. J. R. Bruckner, "Introduction," *Art Against War*, edited by Bruckner, Seymour Chwast, and Steven Heller (New York: Abbeville Press, 1984), p. 9.

"IN COUNTRY"

1. Death, the daily face-to-face confrontation with mortality.

2. Jim Kurtz, in Judith Coburn, "The Last Patrol: Vietnam Vets Return to the Battlefield," *Mother Jones*, February–March 1987, p. 45.

3. Joan Seeman Robinson, "Essential Links," *Since Vietnam: The War and Its Aftermath*, Chapman College, Orange, California, September–October 1984.

4. W. D. Ehrhart, in Samuel G. Freedman, "The War and the Arts," *The New York Times Magazine*, March 31, 1985, p. 51.

5. Tim O'Brien, in Freedman, p. 56.

6. Bernard Edelman, "Curator's Statement," in brochure for "Buddies," The New York State Vietnam Memorial Gallery, Albany, May–September 1984.

7. Michael Aschenbrenner, letter to the author, January 9, 1988.

8. Michael Aschenbrenner, "Analysis: Personal Imagery," *Glass Society Journal*, 1984–85, p. 70.

9. Sondra Varco, in Freedman, p. 55.

10. John Plunkett, letter to the author, 1988.

11. William Broyles, Jr., *Brothers In Arms* (New York: Alfred A. Knopf, 1987), p. 89.

12. Specialist 4 Arthur E. "Gene" Woodley, Jr., in Terry, pp. 244, 254.

13. Although there were 78,751 soldiers missing in action after World War II, prolonged searches did not take place and political hay was not made from them. There are few left unaccounted for from Vietnam now, but they have attracted an exaggerated level of attention, spurred on by films like *Rambo*.

14. Theodore William Gostas, statement for the Air Force Art Collection, 1982, unpublished.

15. Anonymous, in *Women in the Wake of War: A Report on the "Vietnam Era Women's Project,"* compiled by Virginia Olsen Baron for Church Women United, Cincinnati, 1977, p. 15. This small book covers all aspects of women's experiences in the war, from those in Vietnam to those at home with any relationship to the war, during and since. (Available for $1.00 from Box 37815, Cincinnati, OH 45237.)

16. Anonymous, in *Women in the Wake of War*, p. 18.

17. Anonymous, in *Women in the Wake of War*, p. 14.

18. John Knecht, statement for show at the Center for Exploratory and Perceptual Arts (CEPA), Buffalo, 1985.

19. Peter Marin, "What the Vietnam Vets Can Teach Us," *The Nation*, November 27, 1985, p. 235; reprinted in *Vietnam: The Battle Comes Home*, photographs by Gordon Baer, edited by Nancy Howell-Koehler, pp. 39–48.

20. Because there was no way in an exhibition limited to some 100 objects to include enough photographs to be representative of the photographic contribution to the Vietnam era, I chose to omit all but three groups of images: by a vet, a war correspondent, and a woman who has concerned herself with the vets since the war. The Washington Project on the Arts has circulated the extensive photography section of its Vietnam exhibition—"War and Memory"—so I have left the job up to them.

21. Philip Jones Griffiths, *Vietnam Inc.* (New York: Collier Books, 1971), p. 4. *Karma* is a 1985 film by the Vietnamese director Ho Quang Minh, set in South Vietnam in the late '60s with a plot directly related to this statement.

22. There has been little art by those who sought on principle to avoid the draft, among whom were Wiley Sizemore, who made a small "conceptual" piece in 1982 that documented his selective service papers, physical and medical exams. In 1968 Tony Ramos made a videotape called *About Media*, which referred to the media's coverage of his own flight to Canada. When Martin Luther King was killed, Ramos returned to organize with the resistance in Boston. He took sanctuary in a church in Providence, Rhode Island; the FBI dragged him out, and he spent two years in jail, until Carter declared amnesty for anti-Vietnam War political prisoners. Ramos was interviewed by Gabe Pressman on Channel 5; for *About Media* he videotaped the interview, then turned it around to interview Pressman.

23. William Short, letter to the author, 1987.

24. Michael Herr, *Dispatches* (New York: Avon, 1978), p. 66.

25. Steve Durland, "Back From the Front," *High Performance*, no. 25 (1984), pp. 26–29.

26. Kim Jones, quoted in Durland, p. 28.

27. Marin, p. 40.

28. Brian Willson, talk at the University of Colorado, Boulder, March 11, 1988.

29. Tom Bird, quoted in Jo-Ann Mort, "Vietnam Vets Perform for the Homeless," *Democratic Left*, September–October, 1987, p. 43. Cf. Sue Coe's *War Train*, fig. 74.

30. Dave Evans, in Coburn, p. 39.

IN RETROSPECT

1. The ultimate denial, not only of facts or events, but of reality itself.

2. Herr, pp. 276, 278.

3. Maya Lin, quoted in Elizabeth Hess, "Vietnam: Memorial of Misfortune," in Reese Williams, ed., *Unwinding the Vietnam War: From War Into Peace* (Seattle: The Real Comet Press, 1987), p. 264.

4. See note 3.

5. Hess, p. 265.

6. See *Nothing to Lose*, the newsletter of Vietnam Veterans United to Prevent World War III, a militant New York-based group that is a constant presence at Vietnam-related events and is particularly interested in reaching today's youth. Now renamed Vietnam Veterans Against the War (Anti-Imperialist), one of its mottoes is "To Hell with Rambo, Ollie North, and All They Represent!" Reaching young people is also the goal of other Vietnam veterans' groups, such as the Smedley Butler Brigade in Boston, which uses art, poetry, video, music, and talks to high school students to convey its antiwar message.

7. A veteran speaking at a panel discussion, "Reflections on the Wall," at Columbia University, November 10, 1987, reported in *Nothing to Lose*, no. 2 (1987).

8. *The New York Times*, January 5, 1989.

9. Roger Brown, interviewed by "R. V." in "Roger Brown: A Universal Language of the Eye," *Dialogue*, vol. 10, no. 5 (1987), p. 28.

10. These objects are kept in the Museum and Archaeological Regional Storage Facility (MARS) near Washington. In 1987 Cynthia Carlson made a series of monotypes based on photographs of the memorabilia titled "Sorry About That."

11. Approximately 67,000 of the 245,000 are children with birth defects, and 40,000 are wives who had miscarried. The lawsuit was settled out of court, with a totally disabled veteran receiving only $1,200. Protests and denials continue. Research is now being conducted by twelve state agencies as the federal government continues to drag its feet. (See Jane Gardner, "Answers at Last," *The Nation*, April 11, 1987.) Only in 1988 did the Air Force even admit publicly that dioxin "can't be ruled out" as the cause of all these health problems.

12. Frances Fitzgerald, *Fire in the Lake: The Vietnamese and Americans in Vietnam* (New York: Vintage Books, 1973), p. 568.

13. Jeff Kelley, *William T. Wiley*, Fuller-Goldeen Gallery, San Francisco, 1983.

14. A moving 25-minute color film (*Kim Phuc*) was made about the subject as an adult by Manus van de Kemp in 1984. (It is distributed by Icarus Films.)

15. Chi Le, quoted by Allan Jalon, "Refugee Artists Display the Pain of Powerlessness," *Los Angeles Times*, November 8, 1987.

16. Anonymous veteran, quoted in Myra McPherson, *Long Time Passing: Vietnam and the Haunted Generation* (Garden City: Doubleday, 1984), pp. 53–54.

17. Noam Chomsky, "Intervention in Vietnam and Central America: Parallels and Differences," *Clinton Street Quarterly*, Winter 1986, p. 46.

18. Robert Olen Butler, *The New York Times*, August 4, 1987.

19. Ronald Reagan, "Main Street Americans" speech, February 1982, quoted in Gregory Lukow's important article "Anniversaries of Defeat: Post-Vietnam Revisionism and the Commodification of Cynicism," *Journal*, Winter 1986, p. 60.

20. Edward Said, "In the Shadow of the West," *Wedge*, no. 7–8, Winter–Spring 1985, p. 4.

21. Rudolf Baranik, letter to the editor, *Art in America*, September–October 1975, p. 36.

22. Donald Kuspit, "Golub's Assassins: An Anatomy of Violence," *Art in America*, May–June 1975, p. 63.

APPENDIX

A CALL FOR THE IMMEDIATE RESIGNATION OF ALL THE ROCKEFELLERS FROM THE BOARD
OF TRUSTEES OF THE MUSEUM OF MODERN ART

There is a group of extremely wealthy people who are using art as a means of self-glorification and as a form of social acceptability. They use art as a disguise, a cover for their brutal involvement in all spheres of the war machine.

These people seek to appease their guilt with gifts of blood money and donations of works of art to the Museum of Modern Art. We as artists feel that there is no moral justification whatsoever for the Museum of Modern Art to exist at all if it must rely solely on the continued acceptance of dirty money. By accepting soiled donations from these wealthy people, the museum is destroying the integrity of art.

These people have been in actual control of the museum's policies since its founding. With this power they have been able to manipulate artists' ideas; sterilize art of any form of social protest and indictment of the oppressive forces in society; and therefore render art totally irrelevant to the existing social crisis.

1. According to Ferdinand Lundberg in his book, The Rich and the Super-Rich, the Rockefellers own 65% of the Standard Oil Corporations. In 1966, according to Seymour M. Hersh in his book, Chemical and Biological Warfare, the Standard Oil Corporation of California - which is a special interest of David Rockefeller (Chairman of the Board of Trustees of the Museum of Modern Art) - leased one of its plants to United Technology Center (UTC) for the specific purpose of manufacturing napalm.

2. According to Lundberg, the Rockefeller brothers own 20% of the McDonnell Aircraft Corporation (manufacturers of the Phantom and Banshee jet fighters which were used in the Korean War). According to Hersh, the McDonnell Corporation has been deeply involved in chemical and biological warfare research.

3. According to George Thayer in his book, The War Business, the Chase Manhattan Bank (of which David Rockefeller is Chairman of the Board) - as well as the McDonnell Aircraft Corporation and North American Airlines (another Rockefeller interest) - are represented on the committee of the Defense Industry Advisory Council (DIAC) which serves as a liaison group between the domestic arms manufacturers and the International Logistics Negotiations (ILN) which reports directly to the International Security Affairs Division in the Pentagon.

Therefore we demand the immediate resignation of all the Rockefellers from the Board of Trustees of the Museum of Modern Art.

New York, November 10, 1969
GUERRILLA ART ACTION GROUP
Jon Hendricks
Jean Toche

COMMUNIQUE

Silvianna, Poppy Johnson, Jean Toche and Jon Hendricks entered the Museum of Modern Art of New York at 3:10 pm Tuesday, November 18, 1969. The women were dressed in street clothes and the men wore suits and ties. Concealed inside their garments were two gallons of beef blood distributed in several plastic bags taped on their bodies. The artists casually walked to the center of the lobby, gathered around and suddenly threw to the floor a hundred copies of the demands of the Guerrilla Art Action Group of November 10, 1969.

They immediately started to rip at each other's clothes, yelling and screaming gibberish with an occasional coherent cry of "Rape." At the same time the artists burst the sacks of blood concealed under their clothes, creating explosion of blood from their bodies onto each other and the floor, staining the scattered demands.

A crowd, including three or four guards, gathered in a circle around the actions, watching silently and intently.

After a few minutes, the clothes were mostly ripped and blood was splashed all over the ground.

Still ripping at each other's clothes, the artists slowly sank to the floor. The shouting turned into moaning and groaning as the action changed from outward aggressive hostility into individual anguish. The artists writhed in the pool of blood, slowly pulling at their own clothes, emitting painful moans and the sound of heavy breathing, which slowly diminished to silence.

The artists rose together to their feet, and the crowd spontaneously applauded as if for a theatre piece. The artists paused a second, without looking at anybody, and together walked to the entrance door where they started to put their overcoats on over the bloodstained remnants of their clothes.

At that point a tall well-dressed man came up and in an unemotional way asked: "Is there a spokesman for this group?" Jon Hendricks said: "Do you have a copy of our demands?" The man said: "Yes but I haven't read it yet." The artists continued to put on their clothes, ignoring the man, and left the museum.

NB: - According to one witness, about two minutes into the performance one of the guards was overheard to say: "I am calling the police!"
- According to another witness, two policemen arrived on the scene after the artists had left.

New York, November 18, 1969
GUERRILLA ART ACTION GROUP
Jon Hendricks
Poppy Johnson
Silvianna
Jean Toche

FURTHER READING

The references listed below are not in the notes and include only those publications that stress or at least include the visual arts. The general literature on Vietnam is enormous.

Berger, Maurice. *Representing Vietnam: The Antiwar Movement in America.* New York: Hunter College Art Gallery, 1988. Includes a major essay.

Clifton, Merritt, ed. *Those Who Were There.* Paradise, Calif.: Dustbooks, 1984. Bibliography of eyewitness accounts.

Cohen, Steve. *Vietnam Anthology and Guide to a Television History.* New York: Alfred A. Knopf, 1983.

Cultural Critique. "American Representations of Vietnam," special issue. No. 3, Spring 1986.

The Guerrilla Art Action Group. *GAAG: A Selection.* New York: Printed Matter, 1978. A lively compendium of the group's works, including a large number from the Vietnam period; exudes the flavor of the times.

Howell-Koehler, Nancy, ed. *Vietnam: The Battle Comes Home: A Photographic Record of Post-Traumatic Stress with Selected Essays.* Dobbs Ferry, N.Y.: Morgan & Morgan, 1984. Photographs by Gordon Baer; articles by Robert Lifton, M.D., and Peter Marin, among others.

Kardon, Janet, ed. *1967, At the Crossroads.* Philadelphia: Institute of Contemporary Art, 1987. Exhibition catalogue with texts by Kardon, Hal Foster, Lucy R. Lippard, Barbara Rose, Irving Sandler.

Kunzle, David. *Art as a Political Weapon: American Posters of Protest 1966–70.* New York: New School Art Center, 1971. Invaluable catalogue of posters with detailed descriptions.

Lippard, Lucy R. *Get the Message? A Decade of Art for Social Change.* New York: E. P. Dutton, 1984. Includes "The Dilemma," "The Art Workers' Coalition: Not a History," and other essays from the Vietnam period.

Marmer, Nancy. "Art in Politics '77." *Art in America,* July–August 1977, p. 64.

Newman, John. *Vietnam War Literature: An Annotated Bibliography of Imaginative Works about Americans Fighting in Vietnam.* 2d ed. Metuchen, N.J.: The Scarecrow Press, 1988.

Philbin, Marianne, ed. *Give Peace a Chance: Music and the Struggle for Peace.* Chicago: Chicago Review Press, 1983. Catalogue of an exhibition at the Peace Museum, Chicago. Texts by Yoko Ono, Pete Seeger, Joan Baez, among others; includes "Bibliography/Discography."

Pindell, Howardena. *The War Show.* Catalogue of exhibition at the Art Gallery, Fine Arts Center, State University of New York, Stony Brook, March–April 1983. Curated and written by Pindell; includes Vietnam-related works by Mel Edwards, Golub, Kearns, Sakoguchi, Spero.

Robinson, Joan Seeman. *They Ruled the Night: The Vietnam War and the Visual Arts,* work in progress.

Rogovin, Janice. *Let Me Tell You Where I've Been.* Janice Rogovin, Jamaica Plain, Massachusetts, 1988. A beautifully produced artist's book of photographs and extensive interviews with seven Vietnam veterans, compiled over a seven-year period and dedicated to the author's cousin, who died at Hamburger Hill.

Schwartz, Therese. "The Politicization of the Avant-Garde." *Art in America,* Part I, November–December 1971; Part II, March–April 1972; Part III, March–April 1973; Part IV, January–February 1974.

Spencer, Duncan, and Lloyd Wolf. *Facing the Wall: Americans at the Vietnam Veterans Memorial.* New York: Collier Books, 1986. The portraits and testimonies of visitors.

Sundell, Nina Castelli, ed. *The Turning Point: Art and Politics in Nineteen-Sixty-Eight.* New York: Lehman College Art Gallery, City University of New York, 1968. Good '60s bibliography.

The Washington Project for the Arts. *War and Memory: In the Aftermath of Vietnam.* Washington, D.C., 1987. The multidisciplinary program of art, film, video, theater, literature, music, and public discussions that accompanied this important exhibition. There is no catalogue per se of the installations and photographs included, but a major book was published in conjunction with the show; see Williams, below.

Williams, Reese, ed. *Unwinding the Vietnam War: From War Into Peace.* Seattle: The Real Comet Press, 1987. An unusual collection of essays, poetry, and memoirs about Americans and Vietnamese. Among the contributors: John Ketwig, Jane Creighton, Tran Van Dinh, Bobbie Ann Mason, Robert Bly, Noam Chomsky, Adrienne Rich, Kim Jones, and Craig Adcock on Terry Allen.

E X H I B I T I O N C H E C K L I S T

Height precedes width precedes
depth.

TERRY ALLEN
1. *Boogie Chillin*, 1988
Mixed-media, 32 × 72 × 3"
Collection of the artist, through the
courtesy of the Gallery Paule Anglim,
San Francisco

BERNARD APTEKAR
2. *Our Men and Their Works*,
1968–70
Painted masonite, 70 × 96 × 36"
Courtesy of the artist

MICHAEL ASCHENBRENNER
3. *Damaged Bone Series: Chronicles
1968*, 1982
Glass, cloth, wire and twigs, 96 × 77"
Courtesy of the artist

RUDOLF BARANIK
4. *Napalm Elegy I*, 1966–74
Oil on canvas, 72 × 72"
Courtesy of the artist

BRUCE BARBER
5. *Remembering Vietnam*, 1985–86
Photographs with text, 60 × 120"
Courtesy of the artist

KEIKO BONK
6. *Dad*, 1986
Oil on canvas, 54 × 54"
Courtesy of the artist

7. *Mom*, 1986
Oil on canvas, 54 × 54"
Courtesy of the artist

KAY BROWN
8. *The Black Soldier*, 1969
Collage, 48 × 36"
Courtesy of the artist

ROGER BROWN
9. *Vietnam Commemorative*, 1982
Oil on canvas, 82 × 143 1/2"
Courtesy of the Phyllis Kind Gallery,
Chicago and New York

LUIS CAMNITZER
10. *The beginning couldn't be traced*,
from the "Agent Orange" series,
1984–86
Color photo-etching, 30 × 22"
Courtesy of the artist

11. *Eventually shadows too, were
cancelled*, from the "Agent Orange"
series, 1984
Color photo-etching, 30 × 22"
Courtesy of the artist

12. *For years they didn't go near it*,
from the "Agent Orange" series, 1984
Color photo-etching, 30 × 22"
Courtesy of the artist

13. *Then they waited*, from the
"Agent Orange" series, 1985
Color photo-etching, 30 × 22"
Courtesy of the artist

14. *They gave him an ointment*, from
the "Agent Orange" series, 1985
Color photo-etching, 30 × 22"
Courtesy of the artist

15. *Her own harvest, too, would be
different*, from the "Agent Orange"
series, 1986
Color photo-etching, 30 × 22"
Courtesy of the artist

JAMES CANNATA
16. *They Killed Many of My Men*,
1984
Color photographs/cliche verre,
20 × 24" each
Courtesy of the artist

JACK CHEVALIER
17. *My Vietnam*, 1987–88
Mixed-media on wood,
121 1/2 × 59 1/2"
Courtesy of the artist and the Linda
Hodges Gallery, Seattle

CHI LE
18. *The Butcher Shop*, 1984
Acrylic and mixed-media on cotton,
95 × 66 1/2"
Courtesy of the artist

SUE COE
19. *War Train*, 1986
Mixed-media on paper, 59 3/4 × 51"
Courtesy of the artist

ROBERT COLESCOTT
20. *Bye Bye Miss American Pie*, 1971
Acrylic on canvas, 78 3/4 × 58 3/4"
Courtesy of the artist

PETER DEAN
21. *No. 1 Cannibal*, 1967
Oil on canvas, 20 × 16"
Courtesy of the artist

MICHELE OKA DONER
22–23. *Death Masks*, 1967
Ceramic, 6 × 5" each
Private Collection, Miami Beach

24–25. *Death Masks*, 1967
Ceramic, 6 × 5" each
Private Collection, Miami Beach

JAMES DONG
26. *Vietnam Scoreboard*, 1969
Etching, 20 5/8 × 27 1/2"
Courtesy of the artist

OYVIND FAHLSTROM
27. *CIA Monopoly*, 1971
Acrylic on metal and vinyl,
25 1/2 × 35 1/2"
Courtesy of the Arnold Herstand
Gallery, New York

NANCY FLOYD
28. *The James M. Floyd Memorial*,
1986
Mixed-media installation
Courtesy of the artist

RUPERT GARCIA
29. *Fenixes*, 1984
Pastel on paper, 40 × 78 3/8"
Courtesy of the artist and the
Ianetti-Lanzone Gallery, San
Francisco

LEON GOLUB
30. *Vietnam I*, 1972
Acrylic on canvas, 120 × 336"
Courtesy of the Barbara Gladstone
Gallery, New York

THEODORE GOSTAS
31. *Friend in Need*, 1981
Acrylic on canvas, 20 × 16"
Collection of the United States Air
Force, Washington, D.C.

32. *Butt Stroke*, 1982
Acrylic on canvas, 20 × 16"
Collection of the United States Air
Force, Washington, D.C.

33. *East Is East*, 1982
Acrylic on canvas, 16 × 12"
Collection of the United States Air
Force, Washington, D.C.

34. *Solitary Confinement: Insects
Witness My Agony*, 1982
Acrylic on canvas, 18 × 14"
Collection of the United States Air
Force, Washington, D.C.

PHILIP JONES GRIFFITHS
35. *Children in Refugee Camp*, 1967
Silver gelatin print, 20 × 16"
Courtesy of the artist

36. *Civilian Victims*, 1967
Silver gelatin print, 16 × 20"
Courtesy of the artist

37. *Female Vietnamese Civilian—
Casualty*, 1967
Silver gelatin print, 20 × 16"
Courtesy of the artist

38. *Boy Crying over Dead Sister*,
1968
Silver gelatin print, 16 × 20"
Courtesy of the artist

39. *Refugees from Saigon Fighting*,
1968
Silver gelatin print, 16 × 20"
Courtesy of the artist

40. *Urban Warfare—Saigon*, 1968
Silver gelatin print, 16 × 20"
Courtesy of the artist

41. *VC with Guts Out*, 1968
Silver gelatin print, 16 × 20"
Courtesy of the artist

42. *Traditional Village Life*, 1970
Silver gelatin print, 16 × 20"
Courtesy of the artist

43. *The Computer That Proved the
Vietnam War Was Being Won*, 1970
Silver gelatin print, 16 × 20"
Courtesy of the artist

44. *Wartime Saigon*, 1971
Silver gelatin print, 20 × 16"
Courtesy of the artist

HANH THI PHAM and
RICHARD TURNER
45. *Reconnaissance*, from "Along the
Street of Knives," 1985
Ektachrome print, type R, 24 × 30"
Courtesy of the artists

46. *Asking Questions of Mr. Sky*, from
"Along the Street of Knives," 1985
Ektachrome print, type R, 24 × 30"
Courtesy of the artists

47. *Evening Stroll/Night Patrol*, from
"Along the Street of Knives," 1985
Ektachrome print, type R, 24 × 30"
Courtesy of the artists

48. *Allies Betrayed*, from "Along the
Street of Knives," 1985
Ektachrome print, type R, 24 × 30"
Courtesy of the artists

49. *Detente*, from "Along the Street of
Knives," 1985
Ektachrome print, type R, 24 × 30"
Courtesy of the artists

50. *The Execution*, from "Along the
Street of Knives," 1985
Ektachrome print, type R, 24 × 30"
Courtesy of the artists

WALLY HEDRICK
51. *Anger/Madam Nhu's Bar-B-Q*,
1959
Oil on canvas, 63 × 62 1/2"
Courtesy of the Gallery Paule Anglim,
San Francisco

CARLOS IRIZARRY
52. *Moratorium*, 1969
Silkscreen, 48 × 30"
Courtesy of the Luigi Marrozzini
Gallery, San Juan, Puerto Rico

KIM JONES
53. *Little Marine*, 1988
Mixed-media, 26 × 72 × 10 3/4"
Courtesy of the artist

CLIFF JOSEPH
54. *My Country, Right or Wrong*,
1968
Oil on masonite, 36 × 48"
Courtesy of the artist

JERRY KEARNS
55. *El Norte*, 1987
Acrylic on canvas, 89 × 100"
Courtesy of Kent Fine Art, New York

JOHN KNECHT
56. *Aspects of a Certain History
(Shooting Gallery) #1*, 1983
Gouache on paper, 22 × 30"
Courtesy of the artist

57. *Aspects of a Certain History
(Shooting Gallery) #2*, 1983
Gouache on paper, 22 × 30"
Courtesy of the artist

58. *Image Components for Seven
Alternating Film Loops*, 1983
Gouache on paper, 22 × 30"
Courtesy of the artist

59. *Abusive Amusement*, 1985
Gouache on paper, 22 × 30"
Courtesy of the artist

KARL MICHEL
60. *Loomings*, 1983
Pastel on paper, 30 × 22"
Courtesy of the artist

ROBERT MORRIS
61. *Crater with Smoke*, from "Five
War Memorials," 1970
Lithograph, 24 1/4 × 42 1/2"
Courtesy of Leo Castelli Graphics,
New York

CYNTHIA NORTON
62. *Madonna*, 1985
Acrylic on canvas on wood,
90 × 49 1/2"
Courtesy of the artist

CLAES OLDENBURG
63. *Lipstick Monument Souvenir*,
1969
Painted plaster and cardboard,
6 7/8 × 6 3/8 × 4 3/16"
Collection of Claes Oldenburg and
Coosje van Bruggen, New York

64. *Lipstick (Ascending) on
Caterpillar Tracks*, 1972
Lithograph, 29 3/4 × 23 1/4"
Collection of Claes Oldenburg and
Coosje van Bruggen, New York

MICHAEL PAGE
65. *Pieta*, 1980
Walnut, 28 × 18 × 13"
Courtesy of the artist

IRVING PETLIN
66. *Rubbings from the Calcium
Garden: The Fire Children*, 1972
Oil on canvas, 120 × 96"
Courtesy of the Odyssia Gallery, New
York

JOHN PLUNKETT
67. *Claymores and Barbed Wire*,
1986
Graphite on paper, 22 × 30"
Courtesy of the artist

68. *Nui Ba Din*, 1987
Graphite on paper, 30 × 44"
Courtesy of the artist

RICHARD POSNER
69. *Kent State Memorial Proposal*,
1986
Mixed-media on paper, 33 × 62 1/2"
Courtesy of the artist

RACHAEL ROMERO
70. *He Who Feels It Knows It*, 1984
Acrylic on paper, 30 × 22"
Courtesy of the artist

71. *Vietnam Vet*, 1984
Acrylic on paper, 30 × 22"
Courtesy of the artist

MARTHA ROSLER
72. *Untitled*, from "Bringing the War
Home: House Beautiful," 1969–71
Photomontage, 14 × 11"
Courtesy of the artist

73. *Untitled*, from "Bringing the War
Home: House Beautiful," 1969–71
Photomontage, 14 × 11"
Courtesy of the artist

74. *Untitled*, from "Bringing the War
Home: House Beautiful," 1969–71
Photomontage, 11 × 14"
Courtesy of the artist

75. *Untitled*, from "Bringing the War
Home: House Beautiful," 1969–71
Photomontage, 14 × 11"
Courtesy of the artist

BEN SAKOGUCHI
76. *Agent Orange*, from the
"Vietnam" series, 1979
Acrylic on canvas, 10 × 11"
Private Collection, Pasadena,
California

77. *Bound for Freedom*, from the
"Vietnam" series, 1979
Acrylic on canvas, 10 × 11"
Private Collection, Ben Lomand,
California

78. *Brown Disneyland*, from the
"Vietnam" series, 1979
Acrylic on canvas, 10 × 11"
Private Collection, Pasadena,
California

79. *Hawk*, from the "Vietnam" series,
1979
Acrylic on canvas, 10 × 11"
Private Collection, Ben Lomand,
California

JUAN SANCHEZ
80. *It Is Beautiful to Love the World
with Eyes Not Born*, 1987
Mixed-media on canvas, 44 × 58"
Courtesy of the artist and Guariquen
Inc., Bayamon, Puerto Rico

PETER SAUL
81. *Fantastic Justice*, 1968
Acrylic on canvas, 72 × 50"
Courtesy of the Rena Bransten
Gallery, San Francisco

DAVID SCHIRM
82. *Visions Fill the National
Cemeteries*, 1983
Mixed-media on paper, 22 × 30"
Courtesy of the artist and the Ellen
Sragow Gallery, New York

83. *We Must Not Do This to One
Another*, 1983
Mixed-media on paper, 22 × 30"
Courtesy of the artist and the Ellen
Sragow Gallery, New York

WILLIAM SHORT and
WILLA SEIDENBERG
84. *A Matter of Conscience:
Resistance within the U.S. Military
during the Vietnam War*, 1986–88
Photographs with text, 15 × 24" each
Courtesy of the artists

NANCY SPERO
85. *Bomb*, from the "Bombs and
Helicopters Series," 1966
Ink and gouache on paper, 36 × 25"
Courtesy of the Josh Baer Gallery,
New York

86. *Kill Commies*, from the "Bombs
and Helicopters Series," 1967
Ink and gouache on paper, 36 × 25"
Courtesy of the Josh Baer Gallery,
New York

87. *Search and Destroy*, from the
"Bombs and Helicopters Series,"
1967
Ink and gouache on paper, 25 × 36"
Courtesy of the Josh Baer Gallery,
New York

88. *Helicopter, Pilot and Eagle*, from
the "Bombs and Helicopters Series,"
1968
Ink, gouache, and collage on paper,
39 × 25"
Courtesy of the Josh Baer Gallery,
New York

89. *Sperm Bomb*, from the "Bombs
and Helicopters Series," 1968
Ink and gouache on paper, 25 × 36"
Courtesy of the Josh Baer Gallery,
New York

90. *Victims Attacking Helicopter*,
from the "Bombs and Helicopters
Series," 1968
Ink and gouache on paper, 36 × 25"
Courtesy of the Josh Baer Gallery,
New York

MAY STEVENS
91. *Big Daddy Paper Doll*, 1968
Oil on canvas, 60 × 108"
Courtesy of the artist

RICHARD TURNER
92. *Caesar in Indochina*, 1988
Mixed-media installation
Courtesy of the artist

WENDY WATRISS
93. *Daniel Salmon, San Antonio, Texas*, from the "Agent Orange" series, 1980
Silver gelatin print, 20 × 16"
Courtesy of the artist

94. *John Woods and His Son Jeff, Long Island, New York*, from the "Agent Orange" series, 1980
Silver gelatin print, 16 × 20"
Courtesy of the artist

95. *Dan Jordan and His Son Chad, Austin, Texas*, from the "Agent Orange" series, 1981
Silver gelatin print, 16 × 20"
Courtesy of the artist

96. *Richard Sutton and His Daughter Rachael, Los Angeles, California*, from the "Agent Orange" series, 1981
Silver gelatin print, 16 × 20"
Courtesy of the artist

97. *Two Vietnam Veterans after a Meeting about Agent Orange Exposure, Scranton, Pennsylvania*, from the "Agent Orange" series, 1981
Silver gelatin print, 16 × 20"
Courtesy of the artist

98. *Memorial to Fred Roberto, Fort Lauderdale, Florida*, from the "Agent Orange" series, 1983
Silver gelatin print, 16 × 20"
Courtesy of the artist

99. *Untitled*, from the "Vietnam Veterans Memorial" series, 1982
Silver gelatin print, 16 × 20"
Courtesy of the artist

100. *Untitled*, from the "Vietnam Veterans Memorial" series, 1982
Silver gelatin print, 16 × 20"
Courtesy of the artist

101. *Untitled*, from the "Vietnam Veterans Memorial" series, 1984
Silver gelatin print, 16 × 20"
Courtesy of the artist

102. *Untitled*, from the "Vietnam Veterans Memorial" series, 1986
Silver gelatin print, 16 × 20"
Courtesy of the artist

JOHN WEHRLE
103. *Saigon Managua*, 1987
Mixed-media, 24 × 13 × 10"
Courtesy of the artist

SAM WIENER
104. *Those Who Fail to Remember the Past Are Condemned to Repeat It*, 1970
Mixed-media with mirrors, 14 × 19 × 19"
Courtesy of the artist

WILLIAM T. WILEY
105. *Agent Orange*, 1983
Woodblock print, 54 × 26"
Collection of the artist, through the courtesy of the Fuller-Gross Gallery, San Francisco

106. *Agent Orange, Again*, 1986
Mixed-media, 45 1/4 × 15 3/4 × 6"
Collection of the artist, through the courtesy of the Fuller-Gross Gallery, San Francisco

JOHN WOLFE
107. *Incident near Phu Loc*, 1986
Oil on canvas, 42 × 54"
Courtesy of the artist

CLEVELAND R. WRIGHT
108. *We Regret to Inform You*, 1982
Oil on canvas, 36 × 24"
Courtesy of the artist